Susan K Cleveland

Piping Hot Curves

Accent curves in quilts with piping

Pieces Be With You™

Library of Congress Control Number 2007924283
ISBN 978-0-9792801-0-8

Published by Pieces Be With You™
54336 237th Ave
West Concord MN 55985 USA

www.PiecesBeWithYou.com

Printed by Palmer Printing in the USA

Piping Hot Curves
Table of Contents

Acknowledgements

Quilt photographer • Don Anderson of Anderson's Artistic Photography, Rochester, MN

Editor • Deborah K. Dayman, Pleasant Valley Quiltworks

Test team • The Original Piping Hotties: Leitha Bothun, Nancy Celis, Emily Clay, Synneva Hicks, Beth Holec, Kim Klocke, Barb Lovett, Judy Plank, Sharon Sandberg and Norma Sherwood

Contributors • Beth Holec, Kim Klocke, Synneva Hicks, Sharon Sandberg, Pat Drehobl

Thanks

I try to remember to thank God every day for my wonderful life and gifts which I feel a responsibility to share.

A big thank you to my parents, Bob & Judy Lehms, who think I can accomplish anything...or at least led me to believe that's what they've always thought.

Thanks to my daughter, Erica, who always knows what fabric or color would be best when I'm waffling.

Thanks to my son, Darin, who understands my breaking point and knows when to encourage me to take a breath and have a piece of chocolate.

My dear quilting friends encourage my business endeavors and make a fuss over my quilts. All the success in the world would not be gratifying without buddies to share it with. Norma, Sharon, Leitha, Judy, Beth, Kim, Barb, Nancy, Lynne, Emily and Julie, I thank you. Sorry for my occasional whining.

I'm so thankful my long time friend, Debbie Dayman, was able to be a part of this project. I respect her ideas and welcome her input.

Thank you to all my students and colleagues who make this business fun.

Dedication

To my wonderful hubby, Lee, who encourages me to dive right in and has more confidence in me than I do in myself. We have a great life together!

Introduction
...in the beginning

It began innocently enough. I admired a little quilt in a magazine with a fold of fabric inserted into the binding. I followed the instructions for the little quilt and tried to duplicate the tiny fold of fabric. To my dismay it was wavy, not smooth and neat the way I wanted it to be. My next attempt included corded piping and was a bit more successful. I'm a stickler for workmanship and continued striving for perfect piping. Several attempts later, I had developed a technique to produce perfect piping! Eureka!

One thing lead to another and I found myself teaching my piped binding technique, Piping Hot Binding. It became apparent that several tricks were necessary to enable every quilter to be successful at making piping on his/her machine. The tricks and tips included here will help you make perfect piping on *your* machine. Eventually piping in the binding was not enough. I loved the detail and dimension so much that I began inserting it into my piecing and finally began inserting piping into curves. It's a clever way to avoid curved piecing and opens up new possibilities with fabric choices.

This fun technique will bring detail and dimension to both new patterns and variations of old favorites. Designs traditionally sewn with curved piecing are great candidates for Piping Hot Curves and more contemporary designs with gentle curves are tempting as well. Master the techniques included in this book...your quilts will have a distinctive flair and you may dub yourself a Piping Hottie.

Supplies & Equipment

everything you'll want/need

Fabric

As is the case with many quilting projects, 100% cotton fabric performs the best for Piping Hot Curves. It tolerates heat and steam easily, may be manipulated, and holds a crease. I'm sure other fabrics exist that may also work well, but the projects in this book all contain 100% cotton fabric.

Just a little different way of thinking is required when choosing fabric for a Piping Hot Curves project. Traditionally, we've taken great care to create significant contrast in adjacent pieces. With this technique, however, the contrast must be between the piping fabric and its neighbors. This takes a bit of practice as it involves breaking old habits, but the results are worth it.

Repeating piping fabric elsewhere in the quilt will drawn more attention to the piping. Good examples of this are found in Piping Hot Mexican Lanterns, Piping Hot Macaroni, and Gooney Bird Nests.

Keep in mind the finished piping will be about ⅛" wide. It's just a sliver and we don't want the effort to go unnoticed. If big prints are chosen for the background, piped pieces, or piping, the piping will not stand out. Don't let this happen in your project. Big prints may serve well to tie all fabrics together and look great in a border. Many of the projects in this book began with a wonderful, large scale print which was showcased in a border.

I suggest choosing more subtle prints, tone-on-tones, solids, or, my favorites, hand-dyed solids or textures. Stripes are quite an effective choice for piping as are fabrics with a bit of metallic. Black and white prints always make great piping. Often a fabric of the same color (hue) as other fabrics in a quilt but a lighter or darker version will stand out well as piping.

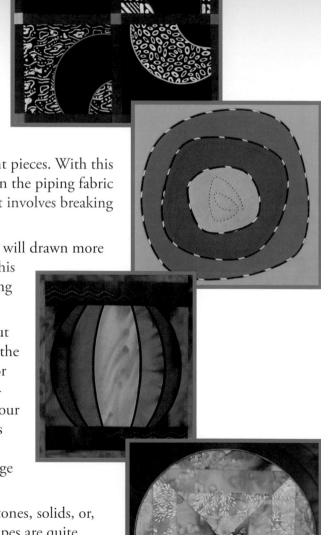

Thread

Success with this technique is largely dependent upon stitching with appropriate threads and needles. For piecing I like 50/3 or 60/2 cotton to match or coordinate with fabrics. For making piping, I prefer 50/3 or 60/2 cotton with one matching thread (either top or bobbin) and the other thread to contrast slightly.

At one point with this technique it is necessary to stitch in the ditch, and bulky or contrasting thread will yield undesirable results. This is one occasion when the thread can determine whether a project is fun and beautiful or miserable and ghastly. Thin, coordinating thread will hide and produce a beautiful seam leaving viewers wondering how the effect was achieved. Choose a thread color to match the fabric on one side of the ditch or the other. I offer these tips for thread/needle choices.

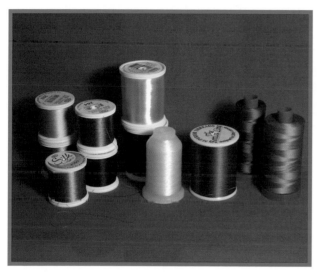

Here are the thread/needle combinations I prefer for ditch-stitching as described in "Apply Piped Shape" on page 20:

• **YLI #100 silk** with a 60/8 Microtex sharp and 50/3 or 60/2 cotton thread in the bobbin. Matching the silk thread's color to one of the fabrics on either side of the ditch gives best results, but a neutral slightly darker than either fabric hides well also.

• **Superior Threads Bottom Line** is a very thin polyester thread which also performs well with this technique. It hides and stitches very well with a 60/8 Microtex sharp and 50/3 or 60/2 cotton thread in the bobbin.

• **Aurifil 50/2 cotton** thread is another option. Stitch with a 60/8 Microtex sharp, 70/10 Microtex sharp, or 70/10 Jeans needle and the same thread in the bobbin.

• **Monofilament** thread has become a popular choice among quilters desiring inconspicuous stitches. If you would like to use monofilament, I suggest testing potential threads for shrinkage. My testing found that monofilaments will shrink when heat and steam is applied. Best results will be achieved with a 60/8 Microtex sharp needle and 50/3 or 60/2 cotton thread in the bobbin.

Quilting threads are purely personal taste. I suggest quilting in the ditch with #100 silk for wall quilts or Aurifil 50/2 cotton for bed or lap quilts. This will keep blocks and borders straight. When it comes to decorative quilting, the sky's the limit but you must be aware that dense quilting on a Piping Hot Curves project is not recommended. Dense quilting will draw up a quilt but cording in piping will not.

FYI...If you think thread size labels are confusing, you're not alone but I may be able to help a bit. Please visit www.YLICorp.com and view their "Thread of Truth" brochure.

Sewing machines

A good sewing machine is a thrill to work with. While a top-of-the line is not necessary, one with **good speed control** is crucial. This technique frequently requires slow, deliberate stitching. If your machine lurches forward when you touch the foot control, do yourself a favor and visit your local dealer! Responsive speed control will help in every aspect of sewing and will take your workmanship to new heights.

Optional needle positions is a feature that is a real treat. Needle positions allow you to stitch a straight line with the needle right or left of center. High-end models have many needle positions with tiny increments while more modest models offer only a few positions but are very worthwhile. It may not be obvious by the buttons on the face of your machine that you have needle position options. Some machines have an image of a needle with + and - buttons to move the needle right and left. Others are less obvious. On some machines, when the stitch pattern is set to straight stitch, the zig-zag width buttons move the needle from right to left. The machine will stitch a straight stitch, but with the needle right or left of center. Sometimes the zig-zag button will move the needle only to the right or to the left, but the mirror image button will enable the needle to go in the other direction. If you're unsure whether or not your machine has optional needle positions, look in the manual under "needle positions".

Needle down is another valuable sewing machine feature. When "needle down" is set to "on", the needle will stop in the down position when you stop sewing. Your work will be held in place while you adjust your hands or reposition your fabric.

A programmable presser foot lifter is also an attractive feature. On some machines it is possible to program the presser foot to stop in the up (lifted) position or in the down position (as usual) when the "needle down" feature is set to "on". When I'm sewing curves, I set the "needle down" feature to "on" and specify the presser foot to stop in the lifted position. This allows me to stop with the needle in my work (to hold it in place) and the presser foot is automatically lifted so I may pivot my fabric without removing my hands from the work to raise the presser foot. What a treat!

A hands-free presser foot lifter also allows the presser foot to be raised without removing your hands from your work. Usually these devices are operated by the right leg, though some are foot-operated.

Sewing machine feet

A grooved foot for making piping can make the experience a happier one. It is possible to make piping with a zipper foot, but a foot with a *little groove* in the bottom produces perfect piping easily. Be wary of "piping" feet, however, as they are typically designed for larger cording than what is appropriate for Piping Hot Curves. If you're inclined to go foot shopping, take a piece of the recommended cording and a strip of

cotton quilter's-weight fabric. When cording is tucked into the fabric's fold, it should ride up into the groove of the foot and slide through it. If the groove is too big, the cording isn't held in place and that foot is not much help. Look for an **applique foot, pintuck foot, or corded buttonhole foot**. More than one groove is OK....in fact it can be quite helpful if your machine has few needle positions.

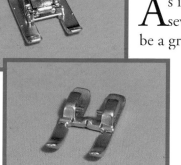

Experiment with several different groove and needle position combinations to determine the best set-up.

As is the case with so many precision sewing tasks, an **open-toe foot** can be a great aid. Throughout this technique it is necessary to see the needle and sew beside a line or in a ditch. Your machine may not have come with an open-toe foot, but it is well worth getting one. You'll be happier with your results.

See "Resources" on page 94 for specific feet recommendations for some machines.

Cording

Cording is available in many sizes and many different fibers. I prefer polyester cording measuring 1.5mm or **¹⁄₁₆″ in diameter**. Every cording manufacturer labels cording differently–that's why I'm stating a measurement as opposed to a labeled size.

Shrinkage is an issue with cording. Even my favorite cording shrinks when exposed to heat and steam. Please see "Perfect Piping" on page 14 for pre-shrinking instructions.

Cotton cording would be nice, but I've found that it clings to cotton fabric and doesn't tuck into the piping's fold easily. Most cotton cording is twisted and produces bumpy piping.

Many quilters are attracted to larger cording thinking they'll get more punch with bigger piping. Bigger cording means more bulk so remember to take this into account when choosing cording. Lumpy seams are no more desirable than lumpy thighs and are even more difficult to hide.

Cording may be found in some quilt shops, in drapery departments of some chain stores, and on the internet. Please see "Resources" on page 94.

Starch

It is beneficial to work with fabric having some body. I like to use **spray starch** on fabrics after they've been washed and dried. Two or three light applications seem to work best. I choose to spray the back of fabrics just in case some flaking or shininess occurs. Simply lay the fabric out, spray a light application of starch, wait for starch to soak into fabric, then press with an iron set for "cotton". Repeat. Use steam if necessary to remove creases but keep in mind steam combined with dampness from starch makes fabric vulnerable to distortion. Steam carefully to avoid distorting fabric. If starch doesn't soak into the fabric before heat is applied, flaking occurs. I prefer to starch only the fabric which will be used for a particular project and I avoid storing starched fabrics. I worry about weakening fibers where starched fabric is folded for a long period of time. This isn't an issue for fabric in a quilt as it softens over time as the quilt is quilted and handled.

Groovin' Piping Trimming Tool

Piping will lay around curves nicer when the seam allowance is about ¼″. It would be nice to be able to sew piping with a small, accurate seam allowance, but this seems impossible. It is much easier and more accurate to sew piping with a strip of fabric wider than what is needed, then use the Groovin' Piping Trimming Tool to trim the seam allowance. A groove in the bottom of the tool holds piping in place while the seam allowance is trimmed. Of course, scissors or an acrylic ruler could be used for this task, but it's rather tedious and inaccurate. Please see "Resources" on page 94 for information on where to find the Groovin' Piping Trimming Tool.

Other supplies/equipment

Needles

I prefer **70/10 Jeans** or **70/10 Microtex sharps** for piecing and **60/8 Microtex sharps** for stitching in the ditch while applying a piped shape. It's easier to sew accurately on a line when sewing with a fine needle.

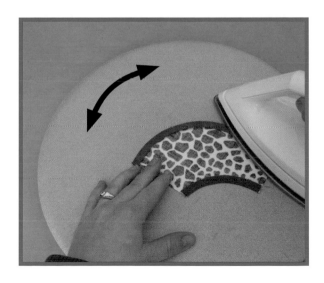

Stiletto (awl)

When sewing accurately, a stiletto can help guide pieces through the machine as they approach the needle. When pressing piped shapes, I also use a stiletto to avoid burning my fingers when smoothing curves. **Clover ball-point awl** is particularly good for this technique as it doesn't poke holes in fabric but allows me to guide pieces when sewing and ironing.

Iron

If your pieces aren't pressing to a crisp fold, you may need a hotter iron. There are occasions when steam is helpful, but please remember to avoid steaming freezer paper as it will create a bond that must be completely saturated with water to loosen. This destroys freezer paper templates and wastes valuable time. Let's not discuss how this was discovered.

Pressing surface

The **Brooklyn Revolver II** makes working with curves easier and faster. One side has a cutting surface while the other has a padded pressing surface. The surfaces spin on bearings so work may be turned to follow the curve with a rotary cutter or iron. A **big pressing surface** is also valuable. Consider buying or making a large rectangular pressing surface to rest on top of your ironing board. An ironing board's curved edge may cause big bows in your yardage or quilts. I use a 4' x 3' pressing surface resting on a drawer unit.

Pins

Pins with a **0.5 or 0.55 mm shaft** will poke a smaller hole in fabric and reduce the chance of distorting pieces as they are pushed through. Pins labeled "Quilter's Pins" are better suited to building a barn.

Masking tape

When applying a piped shape to a background, taping the unit in place is easier than pinning. Tape will allow the piece to lay flat. Avoid using old tape as the adhesive becomes gummy over time and may leave residue on fabric. Pull off a length of tape and stick it onto carpet or fabric to reduce its stickiness. Don't leave tape on fabric for more than an hour or two and avoid exposure to heat. This may cause some adhesive to be left on fabric.

Fabric glue

It may be helpful to use a couple dots of glue, either permanent or removable, to hold the first inch of piping in place as it is applied to fabric beside a freezer paper template. After the piece has been started, this is not necessary for the entire length of piping but does make the first few inches more manageable.

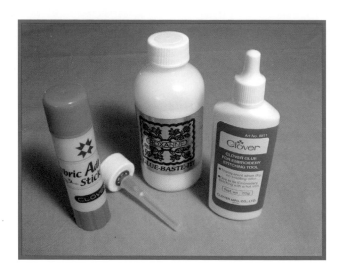

Paper scissors or small rotary cutter

Sharp paper scissors are a must. Freezer paper templates will be used as guides and a crisp edge is essential. An 18mm rotary cutter is another option for cutting freezer paper.

Fabric scissors

Scissors with a rounded, rather than pointed, blade on the bottom make trimming away excess fabric easier with less risk of cutting into the piped piece.

Design wall

It's so nice to be able to arrange blocks on a vertical surface. Nothing fancy is necessary. My first design wall consisted of a piece of white flannel fabric with a sleeve at the top. I inserted a slat through the sleeve and nailed it to the wall.

Post-it Notes®

These are great tools for using as a guide on the bed of the sewing machine. How the pioneers pieced quilts without **Post-it Notes**® and freezer paper is beyond me. In this technique, Post-it Notes® are used as a guide to help make perfect piping.

Freezer paper

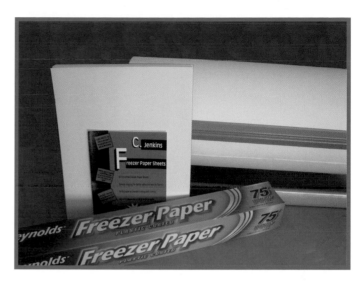

As I understand it, long, long ago freezer paper was used for storing uncooked meat. Thankfully, we've realized the real reason for freezer paper's existence…for quilting. Freezer paper is one of the most valuable tools in my quilting room. I draw templates on the paper side and iron the shiny side to fabric with a dry iron. It may be used as a piping placement guide, piecing template, or quilting template. Quilt shops now carry freezer paper in sheets sized to be used in an ink jet printer. Rolls may be purchased in quilt shops or the food storage section of grocery stores. Very large rolls and wrapping paper dispensers are available online.

A hot iron is necessary for ahereing freezer paper to fabric. Old freezer paper will not adhere to fabric well. If your freezer paper isn't staying put on your fabric, your iron is not hot enough or the freezer paper is very old.

Rotary cutting equipment

Look for rulers with thin lines which are broken frequently so you're able to see the fabric's edge clearly. Avoid shiny cutting mats and mats with a hard surface. Any of the others are great. All cutters work well so the decision is up to you. Remember to change your blade after each project to keep from expending more energy than necessary while cutting. At the beginning of each project, expose the cutter's blade and roll it along your cutting mat. If the cutter does not turn easily, place one finger on the hub and loosen the nut. Cutting with a tight cutter will require more energy than using a free-wheeling cutter.

Perfect Piping

smooth and thin

Prepare strips and cording

• Cut appropriate number of 1¼″ bias strips. Place 45 degree line of ruler along selvage of single layer of fabric. Cut, then cut strips from this edge. When ruler no longer reaches from edge to edge, fold fabric as shown (cut edge over itself) to make more cuts.

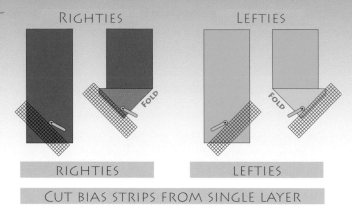

CUT BIAS STRIPS FROM SINGLE LAYER

• Splice strips. Place right sides together making the corner of a square and sew from crevasse to crevasse. The angle of the strips' ends doesn't matter. Use 1.5mm stitches, press seam allowances open and trim to about ¼″.

SPLICE STRIPS

• Press strip in half the long way, wrong sides together. Leaving the cut edges slightly askew will make it easier to open the strip and insert cording.

PRESS WRONG SIDES TOGETHER

• Pre-shrink cording with steam.

STEAM TO PRE-SHRINK CORDING

Sew perfect piping

- Thread machine with *matching* thread on top and slightly *contrasting* thread in bobbin or vice versa.

- Place foot on machine. A foot with a small groove is preferred but a zipper foot will do.

- Tie a knot in end of cording and tuck cording tightly into piping fabric's fold.

- Lower foot over piping. If using a zipper foot place foot beside cording. If using a foot with a groove, place groove over cording.

- Place 8-10 Post-it Notes® beside fold and just in front of feed dogs. Secure with tape. This will keep piping feeding into the machine straight… no more lumpy piping.

- Pull cording into fold and adjust needle position to stitch near cording with 2.0mm stitch length. (Check your machine's manual if you're not familiar with needle positions.) Work a few inches at a time. Smooth piping is more important than tight piping. *Do not catch cording in stitching. Leave enough space for another stitching line between this stitching and cording…barely.*

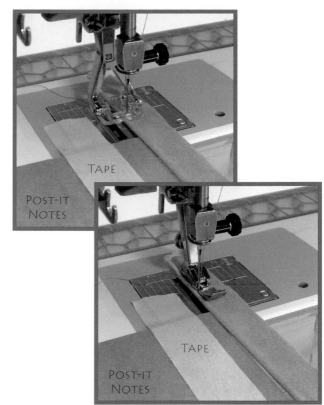

LOWER FOOT ONTO PIPING

ADJUST NEEDLE POSITION

PLACE POST-IT NOTES® BESIDE FOLD

Trim seam allowance

- Trim seam allowance to approximately ¼″ with the Groovin' Piping Trimming Tool, scissors or an acrylic ruler. This thin seam allowance will allow piping to curve nicely.

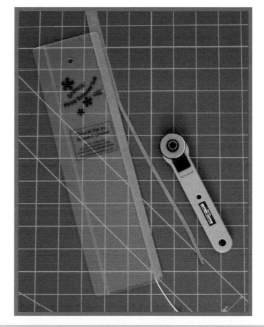

TRIM SEAM ALLOWANCE

The Technique
...how it's done

Make Templates

Freezer paper makes a great guide or template for applying piping to base fabric. Freezer paper may be laid over a pattern (shiny side down) while the pattern piece is traced with pencil or permanent marker. The template may then be cut with paper scissors or rotary cutter and ironed to fabric to be used as a placement or quilting guide.

Freezer paper will shrink slightly when ironed, so templates will be more accurate when made from pre-shrunk freezer paper. To pre-shrink freezer paper, simply lay the shiny side on your pressing surface and press the paper side with an iron set for "cotton". It will adhere to your pressing surface. Peel it off to make templates.

For this technique triple-thick freezer paper templates are desired. When templates are thick it's easier to place piping beside the edge.

When tracing onto freezer paper use a pencil or marker with a fine line and use a straight edge to trace straight lines.

Avoid steam as this will make it difficult to remove freezer paper. If the piece does get steamed, spray with water to remove. This causes tears in the freezer paper and new pieces must be made to continue. (Most of us will experience this only once.)

• Tear or cut off three approximately same-sized pieces of freezer paper and iron each one to your pressing surface individually to pre-shrink.

• Trace template pattern on one of the sheets.

• Press a plain sheet to your pressing surface, press another plain sheet on top of the first, then press the traced sheet on top.

• Cut all layers on solid lines. The layers will stay together throughout the project.

Make Piping

• See "Perfect Piping" on page 14.

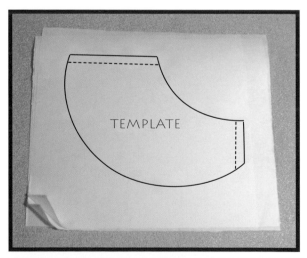

TEMPLATE

TRACE, STACK 3 SHEETS AND PRESS
THEN CUT ON SOLID LINES

Apply Piping

- Press triple-thick freezer paper template to **right** side of fabric. Cut fabric along straight edges and approximately ½" beyond curved edge(s) of template.

PRESS TEMPLATE TO RIGHT SIDE OF FABRIC

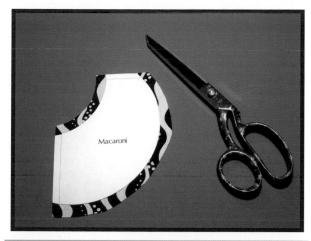

CUT ½" BEYOND CURVED EDGES

- Lay piping along curved edge of template with cording beside template. One side of piping was stitched with slightly contrasting thread. This side should be up (visible) while side with matching or clear thread should be down, on the fabric. It may be helpful to secure the first inch with glue to help get started. Be careful to put glue only on piping's seam allowance, not on portion with cording.

- Stitch close to cording. This new stitching line must be closer to the cord than previous stitching. Thread choice is not crucial at this step but matching thread will give best results. Small, 1.5mm stitches make this task easier. Stop with the needle down and pivot work as necessary.

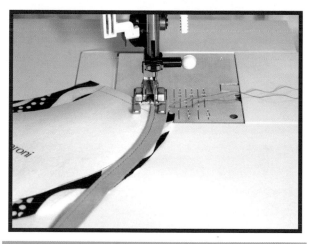

PRESS TEMPLATE TO RIGHT SIDE OF FABRIC

TIPS

I'm right handed and find it easiest to sew curves *clockwise*. This means that sometimes cording is on the right and sometimes it's on the left. Experiment to determine what works for you. You may prefer keeping cording on the same side all the time. Lefties usually prefer sewing *counter-clockwise*.

An *open-toe foot* will allow a better view of the needle.

Moving the needle right or left may put the seam allowance in a better place under the foot and make sewing a smoother curve easier. Make sure the zig-zag throat plate is installed!

Work in *small increments* and stop with the *needle down to pivot* work as needed.

A *stiletto or ball-point awl* will help keep piping in place and may be used to push cording tighter into the fold.

Press/Trim Seam Allowances

TRIM SEAM ALLOWANCE

- Trim base fabric's seam allowance just a bit more narrow than piping's seam allowance. (Applique or blunt-ended scissors will make this task easier.) If shadowing is a concern, trim base fabric's seam allowance a bit wider than piping's seam allowance.

PRESS SEAM ALLOWANCE

- From wrong side, press seam allowances to wrong side. Ends will require extra attention to make sure they don't loose their curve. Take care that there are no pleats or tucks.

TIPS

The *Brooklyn Revolver II* will allow you to turn your pressing surface as you press around curves.

Clipping a seam allowance on an inside curve is necessary if it doesn't lay flat after pressing. This is rarely needed.

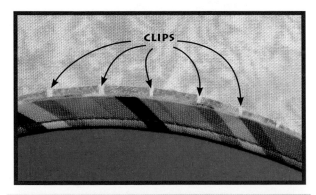

CLIPS

CLIPPING A SEAM ALLOWANCE,
RARELY NECESSARY

NOTE: THIS SEAM ALLOWANCE WAS
TRIMMED WIDER THAN PIPING'S SEAM
ALLOWANCE BECAUSE SHADOWING
WAS A CONCERN

• After pressing from wrong side, turn piece over and check for any areas where piping is uneven. Press from right side smoothing curves. A ball-point awl or stiletto may be used to pull piping into a smooth curve. Please notice that base fabric extends beyond freezer paper template…that's OK. Leave freezer paper on at this point to protect edges from stretching and to stabilize unit as it is applied to background.

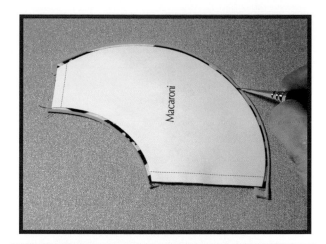

SMOOTH CURVE WITH STILETTO, PRESS

• Some units will require that excess piping be trimmed from straight edges.

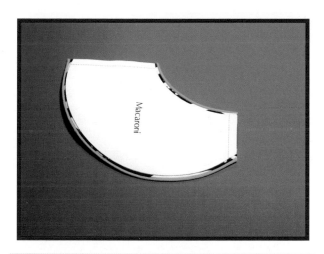

TRIM EXCESS PIPING

Apply Piped Shape

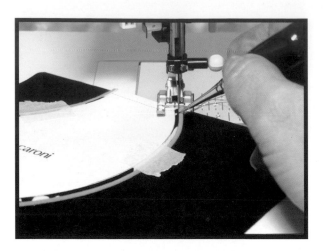

STITCH IN DITCH

- Place piped unit on right side of background fabric. All pieces should be right side up.
- Tape in place with masking tape.

TIPS

Using **tape** keeps the piece flat. Before adhering tape to fabric, tear off several inches and stick on fabric or carpet to add lint to adhesive to reduce its stickiness. Don't leave tape on fabric for more than an hour or two and avoid exposure to heat.

- Stitch in the ditch between piping and piped shape. *Don't remove freezer paper* at this point. Repeat for other curve as necessary.

TIPS

An **open-toe foot** will allow a better view of the needle.

Moving the needle right or left may allow you to sew straighter. Make sure the zig-zag throat plate is installed in order to take advantage of needle positions!

Thin **thread** to match base fabric, piping or invisible will be less noticeable. I prefer YLI #100 silk, Superior Bottom Line, or Aurifil 50 wt. and a 60/8 Microtex sharp needle.

If your machine has the option to decrease **presser foot pressure**, consider trying a lighter pressure as there's significant bulk under the presser foot. Remember to return to its normal setting when finished.

In order to widen the ditch a bit, I suggest running the end of a **stiletto or ball-point awl** in the ditch to move cording tighter into the fold. I also recommend pressing the stiletto into the ditch just ahead of the needle while sewing. Keep the stiletto still and allow fabric to move under it.

I'm right handed and find it easiest to sew curves **clockwise**. This means that sometimes cording is on the right and sometimes it's on the left. Experiment to determine what works for you. You may prefer keeping cording on the same side all the time. Lefties usually prefer sewing **counter-clockwise**.

Remove tape as foot approaches. A **tweezer** makes this easier.

Trim Background (optional)

• On wrong side of block, cut away excess background fabric under piped unit, leaving seam allowance a little wider than the piping's seam allowance. This wider seam allowance will distribute bulk and ultimately produce a flatter block. If background fabric shadowing is a concern, trim seam allowance narrower than piping's seam allowance. Trimming background is optional but quite beneficial for hand quilters as it reduces the number of layers to quilt through.

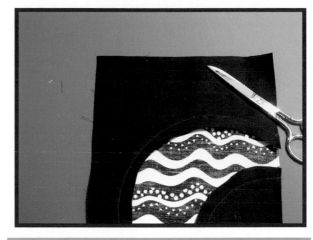

OPTIONAL: TRIM BACKGROUND

TIPS

Applique scissors or scissors with a **blunt tip** will reduce the chance of accidentally cutting into piped unit.

Leaving *freezer paper on* during this step also reduces the chance of cutting into the piped unit.

If an extra layer is not worrisome to you, eliminate this step and leave background fabric in tact.

Finish Block

• Remove freezer paper. If freezer paper is reluctant to come off, warm it with an iron to loosen the adhesive and pull it off while warm. If it still doesn't come off, it was probably steamed at some point and will need to be sprayed with water in order to be removed.

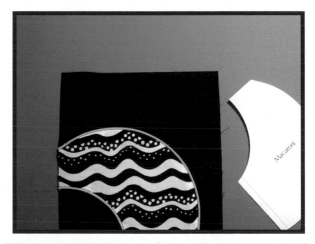

REMOVE FREEZER PAPER

Variations

The macaroni block (as shown on previous pages) is a simple application of the Piping Hot Curves technique, but what about variations? Much can be done to add interest and complexity to a Piping Hot Curves block.

Pieced parts

Piping may certainly be added to a pieced shape and the background may be pieced as well. The Square Peg Round Hole project displays one of these variations in order to add more complexity to the blocks. Rather than piping the pieced "square peg", I piped the "round hole" so that seam allowances didn't need to be pressed back onto themselves. If I'd piped the pieced unit, the "square peg", this would have been the case and the block would have had more bulk.

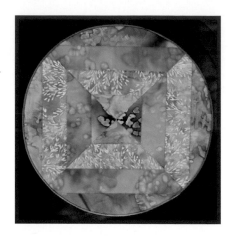

If you choose to pipe a pieced unit, press the unit's seam allowances open then proceed as usual. Please be aware it's not advisable to quilt in the ditch on seams which are pressed open. If you wish to quilt that seam line, use a small zig-zag in order to catch fabric, not just piecing thread.

Foundation

In some cases, too much fabric would be covered up and then wasted if piped units were added to a background fabric. This situation calls for foundation piecing though not in the traditional way. Piping Hot Curves on foundation involves pinning a background piece in place, then adding piped pieces in succession. The work will not be turned upside down as in traditional foundation piecing. The ditch will still be stitched between the piped piece and its piping. With this technique it's beneficial to work with a foundation a bit larger than what is needed and the block will be trimmed after the foundation has been removed. This variation is employed in the project Eye of the Piper.

Back to the beginning

It is possible to pipe a complete circle as in the project Square Peg Round Hole. While in this project a hole is piped, it is also possible to pipe a circle. In both cases, piping comes back to the beginning. Here's how.

- Begin by leaving an inch tail unstitched at the beginning when applying piping.

- Continue applying piping around the circle, then stop about an inch before reaching the beginning.

- Clip and bend beginning tail out into seam allowance.

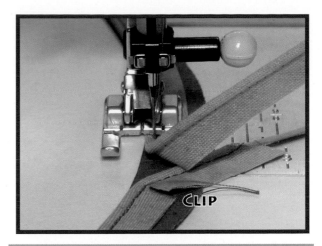

- Lay piping over first ¼″- ½″ of beginning and stitch in place. The ending must ride over beginning for ¼″- ½″.

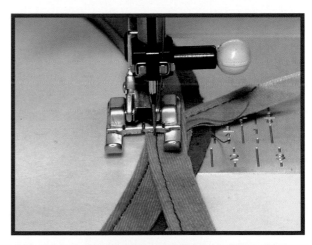

- After the overlap has been stitched, clip and bend ending tail into seam allowance, raise presser foot, move work to jump over cording and stitch another ½″. Cut off extra piping leaving an inch tail.

I avoid stitching into this end of the cording so that it floats inside the casing. This allows cording to be pulled into the piping or cording to be pulled out of the casing if needed.

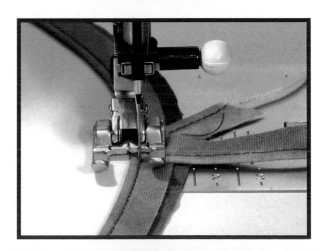

Cutting Basics
accuracy starts here

Cutting cross-grain strips

Most strips will be cut cross-grain.

Fabric should be pre-washed, dried and starched prior to cutting. See "Supplies & Equipment" on page 6 for information on applying starch.

• Fold fabric as it came off the bolt, selvage to selvage. Hold selvages in the air out in front of yourself and slide selvages back and forth until the piece hangs straight.

• Lay folded piece on cutting mat with fold either near you or away.

• Place line of ruler on fold and make cut to straighten end. Cross-grain strips will be cut from this edge.

• Leave ruler on fabric and fold extra yardage up onto mat.

• Turn mat, extra yardage and ruler.

• Unfold extra yardage and cut strips as needed. After about 5 strips have been cut, turn mat again and check to be sure cut edge is perpendicular to fold. Cut a fresh edge if needed, turn mat, and continue cutting strips.

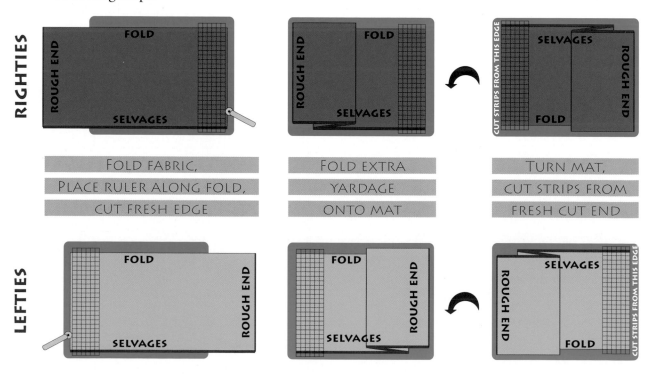

Cutting lengthwise-grain strips

- Straighten first end as described earlier. Turn mat and fabric, slide other end onto mat and straighten second end.

- Unfold fabric and re-fold cut edge to cut edge.

- Straighten edge with selvage in same way first end was straightened. If the piece is too wide for the ruler, bring cut edges to fold before aligning ruler to make cut. Strips will be cut from this edge.

- Leave ruler on piece and fold extra yardage up onto mat.

- Turn mat and extra yardage.

- Unfold extra yardage and cut strips as needed.

RIGHTIES **LEFTIES**

AFTER STRAIGHTENING EACH CUT END, FOLD CUT EDGE TO CUT EDGE,
PLACE RULER ALONG FOLD, CUT FRESH EDGE REMOVING ONE SELVAGE,
THEN FOLD EXTRA YARDAGE, TURN MAT, CUT STRIPS FROM FRESH CUT END

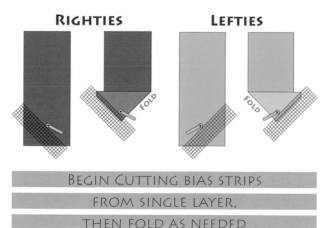

RIGHTIES **LEFTIES**

BEGIN CUTTING BIAS STRIPS
FROM SINGLE LAYER,
THEN FOLD AS NEEDED

Cutting bias strips

- Lay single layer of fabric on cutting mat.

- Place 45 degree line of ruler along selvage.

- Make first cut, then cut strips from this edge. When ruler no longer reaches from edge to edge, fold fabric as shown (cut edge over itself) to make more cuts.

Plain Binding

plump edges, crisp corners

Prepare quilt

- Layer quilt backing, batting, and quilt top.

- Baste with safety pins or thread.

- Using the sewing machine, sew around quilt sandwich less than ¼″ from edge of quilt top. I like to use a walking foot and a long (3mm) stitch length for this. This stitching will be referred to as stay-stitching. Its purpose is to keep the quilt top, batting, and backing from stretching throughout the quilting process.

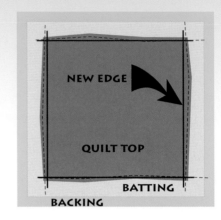

STAY-STITCH, DRAW NEW EDGE

- Quilt. Some stay-stitching may need to be removed to prevent puckers when quilting the outer border.

- Square up quilt by drawing a "new edge". Measure from border seams to determine where to place these lines. (These lines will end up deep into the fold of the binding at the very outside edge of the quilt.) Don't cut excess at this time!

Prepare binding

- Measure around quilt and cut enough 2¼″ strips to go around quilt plus at least 10″ extra. Straight of grain is fine for straight edges, but bias is required for curvy edges. Please note, bias washes and wears better, even on straight edges.

- Make one long strip by splicing strips together with diagonal seams as shown. Use a tiny, 1.5mm stitch length, press seams open, then trim seam allowances to about ¼″.

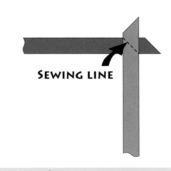

SPLICE STRIPS

- Press long strip wrong sides together the long way.

- Cut end of binding perpendicular to fold, removing any selvage or angled end.

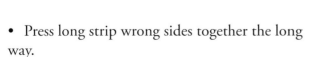

PRESS BINDING WRONG SIDES TOGETHER

- Lay folded binding along "new edge" of quilt top aligning cut edges of binding with "new edge" as shown. End of tail should be about 8″ ahead of corner. Pin in place

- Leave about 6″ of unsewn tail behind machine and begin stitching about 2″ from corner of quilt with ¼″ seam allowance. Stop ¼″ before next "new edge". Lock end of stitching line by either backstitching or by turning and sewing off corner of quilt.

- Remove quilt from machine and clip threads.

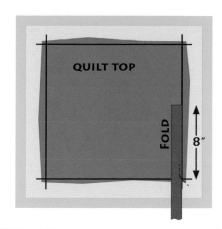

LEAVE 6″ UNSEWN TAIL
STITCH ¼″ SEAM ALLOWANCE
STOP ¼″ BEFORE NEXT NEW EDGE
BACKSTITCH OR SEW OFF CORNER

- To miter corner, turn quilt counter clock-wise one quarter turn as shown. Flip binding up and away from next edge. Important! Next "new edge" and cut edge of binding must be in a straight line! Pin.

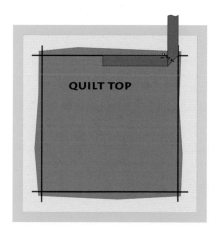

FLIP BINDING AWAY FROM NEXT EDGE
PIN

- Fold binding along next "new edge" making sure binding's fold at quilt's edge is directly over previous "new edge". The placement of this fold determines if the corner of the binding will be square, rounded, or too pointy.

- Begin stitching with a ¼″ seam allowance at binding's fold and stop ¼″ before next "new edge" as done previously. Lock end of stitching by either backstitching or by turning and sewing off corner of quilt.

- Repeat for each corner/side, but after last corner, stop stitching at least 8″ before beginning stitching point. There must be at least an 8″ gap.

FLIP BINDING ALONG NEXT EDGE, STITCH

Join tails (trim then kiss/twist/wiggle)

- Lay tails on top of one another and cut ending tail so it overlaps beginning tail "binding cut width plus ¼". For binding cut 2¼", overlap should be 2½". (trim)

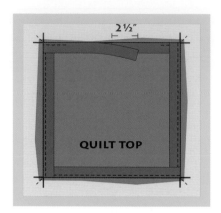

TRIM TAILS LEAVING 2½" OVERLAP

- Unfold tails, place right sides together matching ends. Fold quilt if necessary. (kiss)

UNFOLD TAILS

PLACE RIGHT SIDES TOGETHER

- Turn one tail 90 degrees, so tails make the corner of a square. If this is awkward because too much tail is attached to the quilt, remove some binding stitches so there is more loose tail to work with. It may be necessary to fold the quilt at this point. (twist)

TWIST

- Slide each tail so ⅛" sticks out beyond the other tail. Don't be skimpy with the ⅛"! Pin in place. (wiggle)

- Sew diagonal seam as shown from crevasse to crevasse with small stitches and finger press seam open. Before trimming seam allowance, test the length of binding by folding binding and laying it along the quilt's edge, when you see that it is correct, trim seam allowance to about ¼".

- Finish machine sewing binding to quilt.

- Trim excess along binding's cut edge. Be careful at corners to avoid cutting into binding's fold.

WIGGLE SO EACH TAIL EXTENDS

1/8" BEYOND OTHER

STITCH CREVASSE TO CREVASSE

Finish back

- Wrap binding to back of quilt so the binding is full of backing/batting/quilt top and hand stitch in place. Binding will wrap beyond stitching lines and that's OK. This makes the corners easier to deal with.

- Fold corner bulk on back opposite corner bulk on front.

- Many judges will check to see that binding is stitched down at the mitered corners. While I always do this on the back miter, I stitch front miters on show quilts only.

RIGHTIES	LEFTIES

WRAP BINDING TO BACK PAST STITCHING LINE AND HAND STITCH

FOLD BACK MITER BULK TO OPPOSITE SIDE FROM FRONT MITER BULK

Optional wide binding

Sometimes a wide binding is nice. For a wide binding (about ⅝″ finished), more must be done than simply cutting wider binding strips. Since it's important to stuff binding all the way to the outermost fold, a wider seam allowance must be taken as well. Here are changes necessary to produce a wide binding:

- Cut binding strips 3½″ wide.

- Draw "new edge" keeping in mind seam allowance will be ½″ rather than ¼″.

- Use ½″ seam allowance to sew binding to quilt.

- Stop stitching ½″ before next "new edge" rather than ¼″.

- When cutting ending tail, overlap should be 3¾″ (binding cut width plus ¼″) .

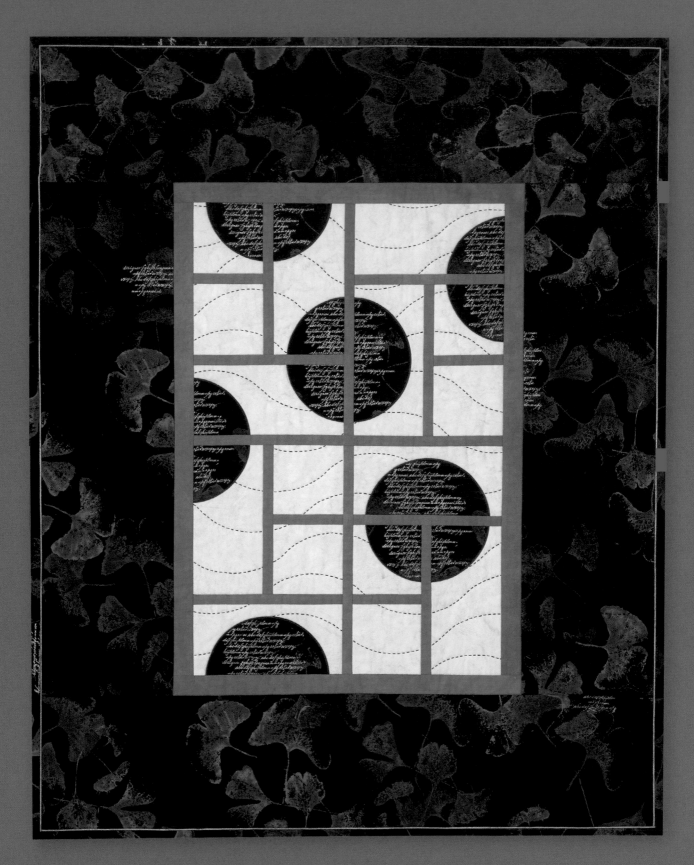

Windows
Susan K Cleveland, 32"x40", 2006

Windows

About this project

This project is the easiest Piping Hot Curves project included in this book. The curve is a gentle, outside curve which does not complete a circle.

This piece creates the illusion of complete circles beneath a lattice, but each partial-circle is actually a unit. Piping will be applied to circles, then circles will be cut into quarter- and half-circle units. This trick enables us to keep the fabric's pattern or motif intact. Cool, huh?

Fabric choices

I first chose a large print for the border and since it had a Japanese flair, I immediately thought of Japanese screens. This large print had areas of script in gold, so it became the obvious choice for the circles. My background fabric is to resemble parchment and the red piping is noticeable but rich. Choosing sashing was difficult but after many auditions, turquoise won out.

The most important decision is the piping fabric. It needs to pop when placed between the background and circle. In this piece, the contrast is less than many other samples in this book, but this keeps the piece a bit more sophisticated.

Supplies (fabric, thread, cording)

Fabric requirements are based on 40–44" wide fabric.

FABRIC/THREAD/CORDING	SHOWN IN SAMPLE	AMOUNT NEEDED
Cording for piping	¹⁄₁₆" or 1.5mm	3 yds
Border	black with gingko leaves	1 yd
Background	parchment	½ yd
Circles	black with gold text	¼ yd (long or fat quarter)
Sashing/Inner border	turquoise	⅓ yd OR (2) fat quarters
Piping	red	fat quarter
Binding (to be cut 2¼")	black with gingko leaves	⅓ yd
Piping in binding (instructions not included)	gold	fat quarter
Backing		1 yd
Thin thread for applying piped circles: YLI #100 silk or another thin thread to match circle/piping fabric or invisible		
Thread for piecing and making piping: #50 or #60 cotton to coordinate with background/sashing/piping fabrics		

Equipment

Please see "Supplies & Equipment" on page 6 for equipment.

• A compass or circle cutter capable of drawing or cutting 6" circles is optional.

Cutting

Results will be better if all fabrics (other than piping fabrics) are starched prior to cutting.

Please see "Cutting Basics" on page 24 for information to cut strips properly. Fabrics normally are cut on crosswise grain, but in this project, the border fabric and background fabric are cut on lengthwise grain.

FABRIC	YOUR FABRIC SELECTIONS	CUTTING INSTRUCTIONS
Piping		• 90″ of 1¼″ bias strips
Background		* Cut single-layer on lengthwise grain. Strips will be about 18″ in length when cut from ½ yd piece. *Non-directional fabric:* • (6) 4″ strips, then cut into (8) 8″x4″ rectangles and (8) 4″ squares *Directional fabric:* • (4) 4″ strips, then cut into (4) 8″x4″ rectangles and (8) 4″ squares • (1) 8″ strip, then cut into (4) 8″x4″ rectangles
Circles		to be cut later
Sashing/ Inner border		If cutting from fat quarters, cut extra strips as needed. • (4) 1″ strips, then cut into › (1) 16″ piece for sashing › (2) 12″ pieces for sashing › (8) 8″ pieces for sashing › (4) 4″ pieces for sashing • (3) 1½″ strips, for inner border which will be cut to length later
Border		* Cut on lengthwise grain. • (4) 7½″ strips about 36″ in length...will be cut to length later
Binding		• 155″ of 2¼″ straight-grain or bias strips
Backing		• 36″x44″

Notes

All seam allowances for piecing are ¼″. I suggest a stitch length of 2.0mm for piecing.

Make piping

Each circle requires 21″ of piping…a total of 84″ is needed. Follow instructions in "Perfect Piping" on page 14. Remember to pre-shrink cording and trim seam allowance of finished piping! The Groovin' Piping Trimming Tool makes this task quick and easy. Use matching thread in the needle and slightly contrasting thread in the bobbin.

Prepare templates

• Make four triple-thick freezer paper circle templates 6″ in diameter and add lines and labels as shown. Use the template on page 39 or use a compass or circle cutter. For this project, each template will be used only once.

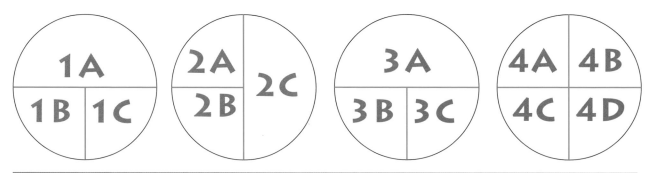

LABEL 6″ CIRCLE TEMPLATES … LINES/NUMBERS/LETTERS

Apply piping to circles

This section will be repeated for each circle.

• With a *dry* iron, press freezer paper templates shiny side down, to *right* sides of chosen fabric. If fabric is directional, note top of circle. Leave 1″ space between templates.

• Cut fabric at least ½″ from template edges. Do not remove freezer paper!

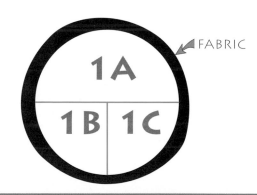

FABRIC

PRESS TEMPLATES TO
RIGHT SIDE CIRCLE FABRIC
CUT FABRIC AT LEAST ½″ BEYOND EDGE

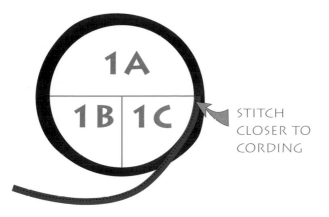

STITCH CLOSER TO CORDING

APPLY PIPING AROUND CIRCLE
BEGIN AND END AT ANY BLUE LINE

• Beginning at any blue line, place piping beside edge of template and stitch close to cording. This new stitching must be closer to cording than piping's stitching line. Continue around circle and end piping at same blue line so ends butt up. (Circles will eventually be cut on blue lines so ends don't need to overlap. Piping ends will be in seam allowances.)

TIPS

See "Apply Piping" on page 17 for details.

Place fold/cording beside template with matching or clear thread down (against fabric)

Use an open-toe foot

Stitch beside cording with 1.5mm stitch length

Try different needle positions

Righties may have best results sewing clockwise and lefties counter-clockwise

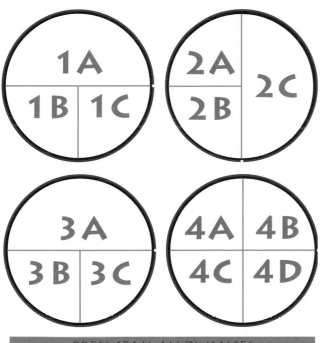

PRESS SEAM ALLOWANCES
TO WRONG SIDE

• Trim circle seam allowance a bit narrower than piping seam allowance. Do not remove freezer paper! If you're concerned about piping fabric shadowing, trim circle seam allowance a bit wider than piping seam allowance.

• From wrong side, press seam allowances to wrong side of circle along stitching line. Do not remove freezer paper!

Leave freezer paper on each unit until it has been applied to background and blocks have been arranged.

TIPS

See "Press/Trim Seam Allowances" on page 18 for details.

Smooth curve from right side with a stiletto and press

CUT PIPED PIECES ON LINES
REPEAT FOR EACH CIRCLE

• Make sure freezer paper is labeled with 1A, 1B, 1C, 2A, 2B... then cut on lines.

• Repeat for each of four circles.

Apply piped quarter- and half-circles

• On design wall, arrange plain background pieces as shown. Pay special attention if your background is directional.

• Place piped quarter- and half-circles on appropriate background squares and rectangles. Align straight edges, center half-circles along edge. Tape in place. Do not remove freezer paper.

• Stitch in the ditch between piping and circles.

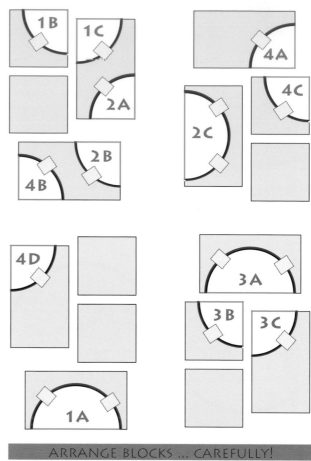

> **TIPS**
>
> See "Apply Piped Shape" on page 20 for details.
>
> Use an open-toe foot
>
> Use thin or clear thread
>
> Stitch with 1.5mm stitch length
>
> Try different needle positions
>
> Hold a stiletto/awl in the ditch while sewing to open the ditch a little
>
> Stop frequently with needle down to pivot
>
> Righties may have best results sewing clockwise and lefties counter-clockwise

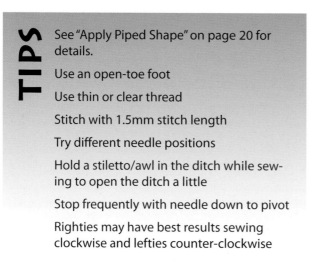

ARRANGE BLOCKS ... CAREFULLY!

APPLY PIPED CIRCLES

• Optional: Trim background from under circles leaving a seam allowance a bit wider than piping's seam allowance. If you're concerned about background fabric shadowing, trim background seam allowance narrower than piping's seam allowance.

• Remove freezer paper leaving blocks in place on design wall. To be safe, you may wish to label each block with a sticker or masking tape to keep everything in order. Take care not to iron labels or masking tape in upcoming steps!

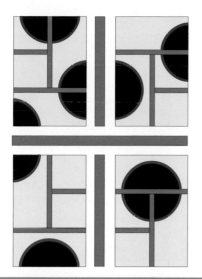

ADD SASHING

Add sashing

Quilt will be pieced in quadrants.

• Add 4″-long sashing between squares pressing seam allowances toward sashing.

• Add 8″-long sashing beside squares and add rectangle on right or left pressing scam allowances toward sashing.

• Add 8″-long sashing between 3-block unit and other rectangle pressing seam allowances toward sashing.

• Add 12″-long sashing between top two quadrants and bottom two quadrants pressing seam allowances toward sashing.

• Add 16″-long sashing between top and bottom halves.

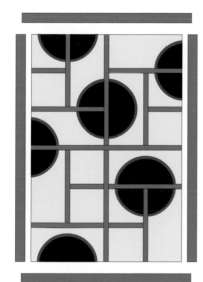

ADD SIDE INNER BORDERS
THEN TOP/BOTTOM INNER BORDERS

Add inner border

Inner border strips were cut earlier but will be cut to length after quilt body is measured.

Side inner border:

• Measure length of quilt and cut (2) previously cut 1½″ inner border strips this length.

• Add those strips to right and left of quilt pressing seam allowances toward sashing.

Top/bottom inner border:

• Measure width of quilt and cut (2) previously cut 1½″ inner border strips this length.

• Add those strips to top and bottom of quilt pressing seam allowances toward sashing.

Add border

- Measure length of quilt through center and cut (2) previously cut 7½″ border strips this length.

- Add those strips to right and left of quilt pressing seam allowances toward border.

- Measure width of quilt through center and cut (2) previously cut 7½″ border strips this length.

- Add those strips to top and bottom of quilt pressing seam allowances toward border.

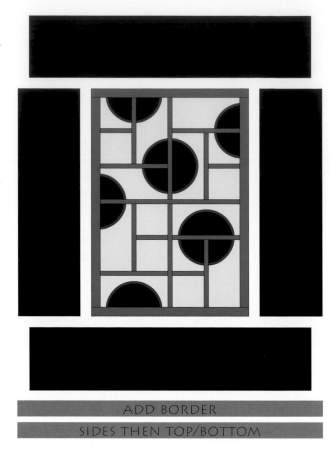

ADD BORDER

SIDES THEN TOP/BOTTOM

Finish

- Please be careful not to add too much quilting. Because this quilt contains cording , the piece will not draw up the way other quilts do when quilted. This is not the place to show off dense quilting. Follow the batting manufacturer's instructions for quilting density, but don't plan dense quilting.

- Stitch in the ditch around blocks, in piping ditches, and on border seams.

- I chose to hand quilt waves across the piece from edge to edge. I used black #8 pearl cotton (in a size 8 between needle) and big quilting stitches reminiscent of sashiko.

- Add a sleeve, label and binding. My **Windows** quilt has piping in the binding as taught in Piping Hot Binding. See "Resources" on page 94.

Circle Template

This project requires (4) triple-thick circle templates. To make triple-thick template(s) see "Make Templates" on page 16. Add labels and straight lines as shown on page 34.

Righties will have best results stitching clockwise and lefties will have best results stitching counter-clockwise. Please record your preference on each template.

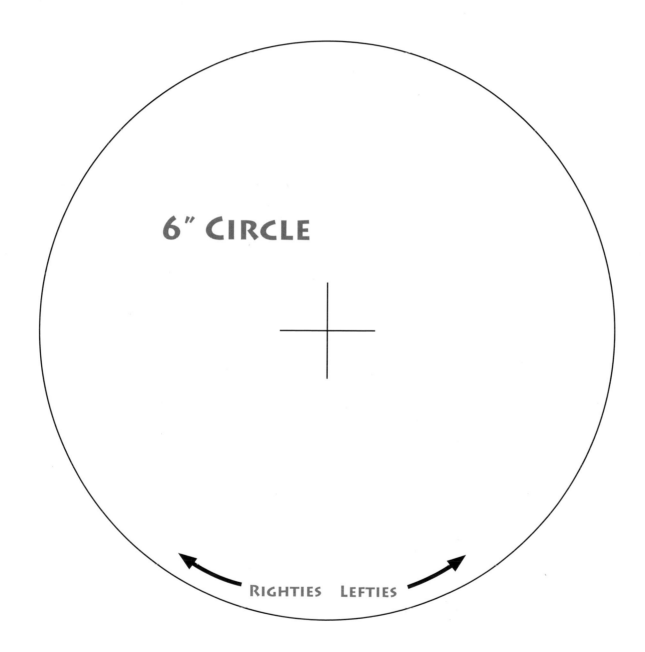

6" CIRCLE

RIGHTIES LEFTIES

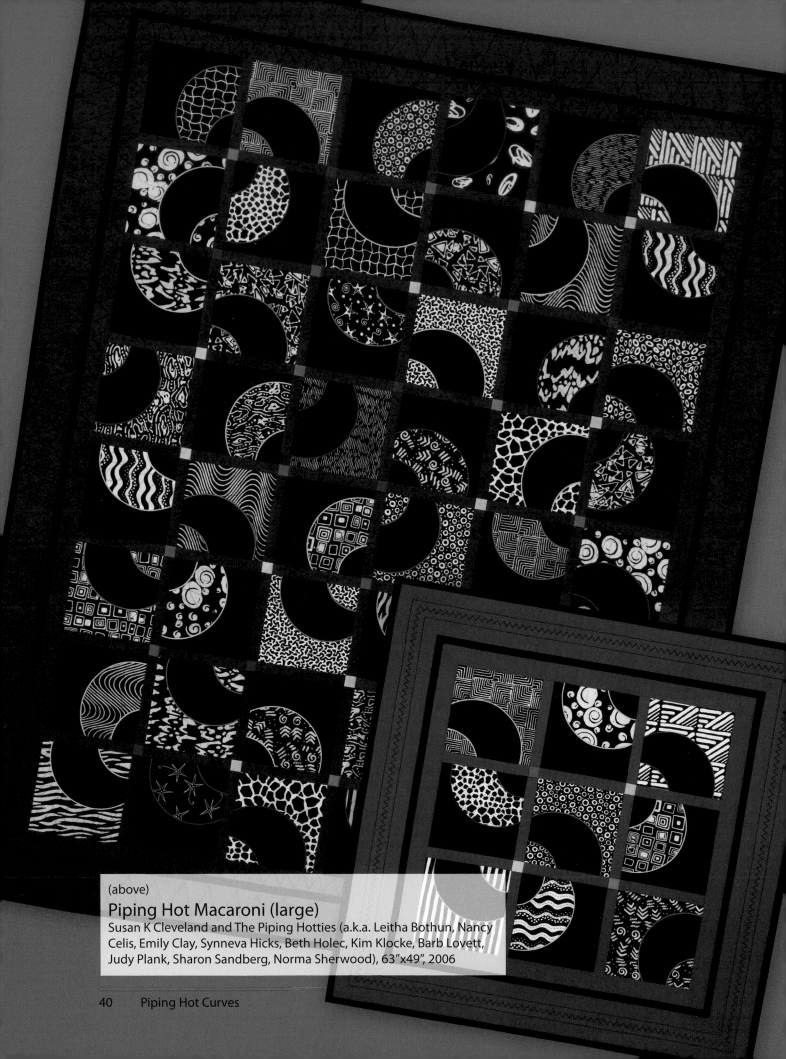

(above)
Piping Hot Macaroni (large)
Susan K Cleveland and The Piping Hotties (a.k.a. Leitha Bothun, Nancy Celis, Emily Clay, Synneva Hicks, Beth Holec, Kim Klocke, Barb Lovett, Judy Plank, Sharon Sandberg, Norma Sherwood), 63"x49", 2006

Piping Hot Macaroni

63"x 49" or 29"x 29"

About this project

This project is quite easy and if you take your time, you're sure to make a nice piece. While the large outside curve is gentle and easy, the smaller, inside curve is tighter and just a bit more difficult. Work slowly and refer back to the technique chapters if the going gets rough. All those tips and tricks will come in handy.

Fabric choices

I used one solid (black) fabric, many black/white prints, and six piping/corner stone fabrics. The bright piping between the solid black and black/white prints gave the definition and contrast I was hoping for.

(opposite)
Piping Hot Macaroni (small)
Susan K Cleveland, 29"x29", 2006

Supplies (fabric, thread, cording)

Fabric requirements are based on 40–44″ wide fabric.

FABRIC/CORDING/THREAD	SHOWN IN SAMPLES	LARGE QUILT AMOUNT NEEDED	SMALL QUILT AMOUNT NEEDED
Cording for piping	¹⁄₁₆″ or 1.5mm	20 yds	5 yds
Backgrounds/Macaronis	B/W prints	(3) ½ yd pieces or (6) fat quarters or (12) fat eights or (48) 6½″ squares	½ yd or (6) 7″ x 14″ scraps or (9) 6½″ squares
Backgrounds/Macaronis/Border 2	black	2 yds	½ yd
Sashing/Borders 1&3	large sample: purple small sample: red	2 yds	1 yd
Piping/Corner stones	orange, yellow, red, green, turquoise, blue	at least (5) fat quarters	(1) fat quarter or many small pieces
Binding (to be cut 2¼″)	black	½ yd	¼ yd
Backing		3 yds	1 yd
Thin thread for applying piped macaronis: YLI #100 silk or another thin thread to match macaroni/piping fabric or invisible			
Thread for piecing and making piping: #50 or #60 cotton to coordinate with sashing/background/macaroni/piping fabrics			

Equipment

Please see "Supplies & Equipment" on page 6 for equipment.

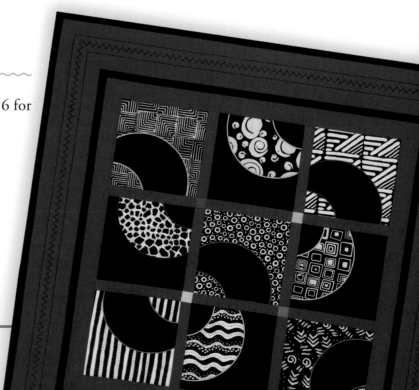

Cutting Instructions

Results will be better if all fabrics (other than piping fabrics) are starched prior to cutting.

Before cutting, review "Cutting Basics" on page 24.

Please pay special attention to cutting instructions as most fabrics are cut normally, on cross-grain, but for large quilt sashing/border fabric is cut on lengthwise grain to avoid seams in border strips.

FABRIC	YOUR FABRIC SELECTIONS	LARGE QUILT	SMALL QUILT
Piping/ Corner stones		• 640" of 1¼" bias strips (13" of piping per block) • (35) 1¼" squares for corner stones	• 130" of 1¼" bias strips (13" of piping per block) • (4) 1¼" squares for corner stones
Backgrounds/ Macaronis		• (24) 6½" squares • Macaronis to be cut later	• (5) 6½" squares • Macaronis to be cut later
Backgrounds/ Macaronis/ Border 2		• (3) 6½" strips, then cut into (24) 6½" squares • Macaronis to be cut later • (4) 1" strips for border 2	• (1) 6½" strip, then cut into (4) 6½" squares • Macaronis to be cut later • (4) 1" strips for border 2
Sashing/ Borders 1&3		* Cut on lengthwise grain, strips will be about 68" in length • (2) 6½" strips, then cut into (82) 1¼"-wide sashing pieces • (4) 3½" strips for border 3 • (4) 1¾" strips for border 1	• (½) 6½" strip, then cut into (12) 1¼"-wide sashing pieces • (4) 3½" strips for border 3 • (4) 1¾" strips for border 1
Binding		• 240" of 2¼" straight-grain or bias strips	• 130" of 2¼" straight-grain or bias strips
Backing		• piece to make 67"x53"	33"x33"

Note

All seam allowances for piecing are ¼". I suggest a stitch length of 2.0mm for piecing.

Make piping

• Each block requires 13″ of piping. 630″ of piping is needed for large quilt and 120″ is needed for small. Use as many different fabrics as you wish. Follow instructions in "Perfect Piping" on page 14. Please remember to pre-shrink cording and to trim finished piping's seam allowance. The Groovin' Piping Trimming Tool makes this task quick and easy. Use matching thread in the needle and slightly contrasting thread in the bobbin.

Prepare templates

• Make at least one triple-thick freezer paper Macaroni template as instructed in "Make Templates" on page 16. This template will be used many times, but you may wish to make several.

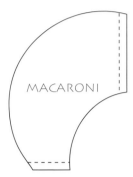

PREPARE TRIPLE-THICK TEMPLATE(S)

Apply piping to macaroni

The next two sections will be repeated for each block. Large: 24 print macaronis and 24 solid macaronis are needed. Small: 4 print macaronis and 5 solid macaronis are needed.

• With a *dry* iron, press freezer paper template, shiny side down, to *right* side of chosen fabric.

• Roughly cut fabric at least ³/8″ beyond curved template edges. Fabric may be cut flush with straight edges of template.

• Sew piping along curves. New stitching line must be closer to cording than piping stitching line.

PRESS TEMPLATES TO **RIGHT** SIDE FABRIC, TRIM ABOUT 3/8″ FROM CURVED EDGES AND ALONG STRAIGHT EDGES

TIPS

See "Apply Piping" on page 17 for details

Place fold/cording beside template with matching or clear thread against fabric

Use an open-toe foot

Stitch beside cording with 1.5mm stitch length

Try different needle positions

Righties may have best results sewing clockwise and lefties counter-clockwise

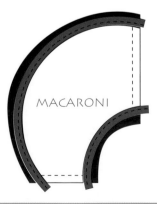

SEW PIPING ALONG CURVES

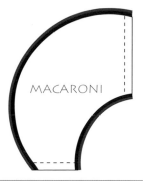

TRIM MACARONI SEAM ALLOWANCE
PRESS TO WRONG SIDE

• Along curved edges, trim macaroni seam allowance a bit narrower than the piping seam allowance. Do not remove freezer paper! (If shadowing is a worry, trim macaroni seam allowance a bit wider than piping seam allowance.)

• From wrong side, press seam allowances to wrong side along stitching line. Do not remove freezer paper!

Leave freezer paper on each unit until it has been applied to background! (Freezer paper may be removed and re-used on other fabrics.)

TIPS

See "Press/Trim Seam Allowances" on page 18 for details

Occasionally, clipping may be necessary on a tight inside curve

Smooth curve from right side with a stiletto and iron

Apply piped macaroni to background

STITCH IN DITCHES
BETWEEN PIPING AND MACARONI

• Place piped macaroni on background square aligning straight edges of macaroni with edges of background. Tape in place.

• Stitch in the ditch between piping and macaroni . Optional: Trim background from under macaroni leaving about a $3/8''$ seam allowance.

• Remove freezer paper so that it may be used on other fabrics.

• Repeat "Apply piping to macaroni" and "Apply piped macaroni to background" to make 9 or 48 blocks.

TIPS

See "Apply Piped Shape" on page 20 for details

Use an open-toe foot

Stitch with 1.5mm stitch length with thin or clear thread

Try different needle positions

Try sewing from different directions

Hold a stiletto/awl in the ditch while sewing to open the ditch a little

Stop frequently with needle down to pivot

Righties may have best results sewing clockwise and lefties counter-clockwise

Assemble quilt body

- Arrange blocks on a design wall.
- Assemble rows as shown. Press seam allowances toward sashing on all rows.
- Sew rows together pressing seam allowances toward sashing/corner stone rows.

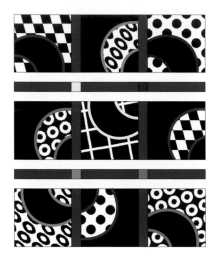

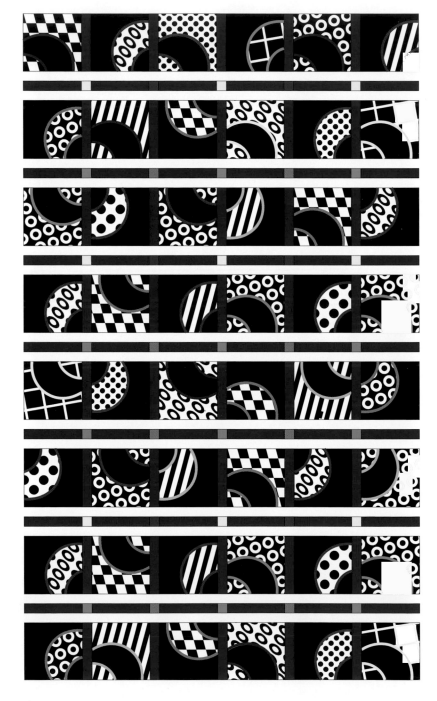

Prepare borders

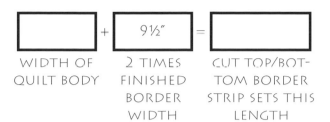

WIDTH OF QUILT BODY + 2 TIMES FINISHED BORDER WIDTH = CUT TOP/BOT-TOM BORDER STRIP SETS THIS LENGTH

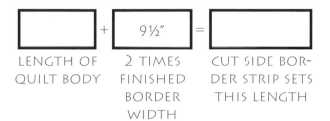

LENGTH OF QUILT BODY + 2 TIMES FINISHED BORDER WIDTH = CUT SIDE BOR-DER STRIP SETS THIS LENGTH

- Measure width of quilt body through the center from cut edge to cut edge and record this measurement. This measurement includes seam allowances.

- Add 2 times finished width of borders. Border strip sets will be cut this length. Twice the finished border width is (1¼″ + ½″ + 3″) x 2 = 9½″.

- Measure length of quilt body through the center from cut edge to cut edge and record this measurement. This measurement includes seam allowances.

- Add 2 times finished width of borders. Border strip sets will be cut this length.

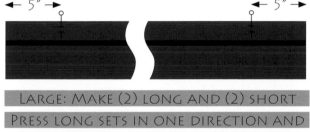

← 5″ → ← 5″ →

LARGE: MAKE (2) LONG AND (2) SHORT
PRESS LONG SETS IN ONE DIRECTION AND
SHORT SETS IN THE OTHER

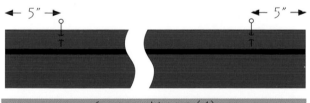

← 5″ → ← 5″ →

SMALL: MAKE (4)
PRESS SIDES IN ONE DIRECTION AND
TOP/BOTTOM IN OTHER DIRECTION
LABEL SIDES AND TOP/BOTTOM

- Large: Cut (2) border 1 strips, (2) border 2 strips, and (2) border 3 strips about 66″ in length and (2) more of each about 52″ in length. Sew border strip sets and press as noted, trim to determined length. Place pins 5″ from each end. (Border strips were cut from yardage earlier.)

- Small: Cut (4) border 1 strips, (4) border 2 strips, and (4) border 3 strips about 32″ in length. Sew border strip sets and press as noted, trim to determined length. Place pins 5″ from each end. (Border strips were cut from yardage earlier.)

When adjacent, or neighboring, border sets are pressed in opposite directions, seam allowances will nest at the mitered seam. It will be beautiful!

Pins will align with seam line intersections marked on wrong of quilt body. Distance from pin to end of strip set equals finished border width plus ¼″. (4¾″ + ¼″ = 5″)

• Mark seam line intersections on back of quilt body at each corner. This intersection will determine where to start/stop stitching when adding borders.

• With quilt body on top, add each border by matching pins with marked intersections and sewing from intersection to intersection. Because borders are mitered, it is necessary to lock stitches at the intersections. You may back stitch, but that produces bulk, so I suggest using tiny 1.0mm stitches at the beginning and end of each seam. The corners will be loose (unattached) and will be stitched together later. Attach each border to the quilt body in this way. Finger press seam allowance toward border. This will prevent previously sewn borders from getting caught as the next border is added. Small: Be sure neighboring border set seam allowances are pressed in opposite directions so they will nest in miters.

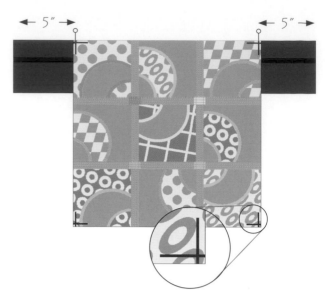

MARK SEAM LINE INTERSECTIONS
ON BACK NEAR CORNERS
ADD EACH BORDER

Miter borders

• Miter border corners. At one corner of quilt, place loose border ends right sides together and tuck quilt body between them. It will be folded diagonally with wrong sides together. Align all cut edges. (If border strip sets were pressed properly, seams will nest together and produce perfect intersections after mitering is complete!) Pin in place and sew from end of the border stitching line to outer corner of border 3. Begin the seam with tiny 1.0mm stitches, then use 1.5mm stitches to complete. Small stitches will produce nicer results when this seam is pressed open. Note: border seams will be pressed in different directions depending on which border is on top.

• Press border-to-quilt body seam allowances toward borders. Press mitered seams open. Trim mitered seam allowances to about ¼″.

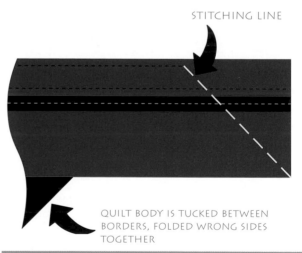

STITCHING LINE

QUILT BODY IS TUCKED BETWEEN BORDERS, FOLDED WRONG SIDES TOGETHER

MITER BORDERS

Finish

Please be careful not to add too much quilting. Because this quilt contains cording in the piping, the piece will not draw up the way other quilts do when quilted. This is not the place to show off dense quilting. Follow the batting manufacturer's instructions for appropriate quilting density, but don't plan dense quilting.

- Stitch in the ditch.
- Quilt blocks and borders.

On the large quilt I machine quilted in the ditch along each sashing strip to outline blocks and in each border seam. I then free-motion machine quilted loopdy-loops in the macaronis and backgrounds and zig-zags in the borders.

On the small quilt I machine quilted in the ditch along each sashing strip to outline blocks and in each border seam. I hand quilted each block with Sulky 12 wt. cotton mimicking the printed fabric's motifs.

- Add binding, label and sleeve.

Macaroni Template

Please see "Make Templates" on page 16 to learn how to make triple-thick freezer paper templates.

Righties will have best results stitching clockwise and lefties will have best results stitching counterclockwise. Please record your preference on each template.

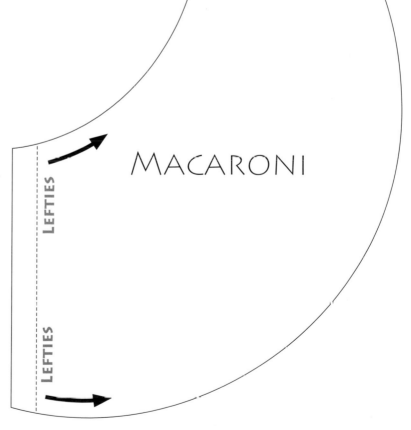

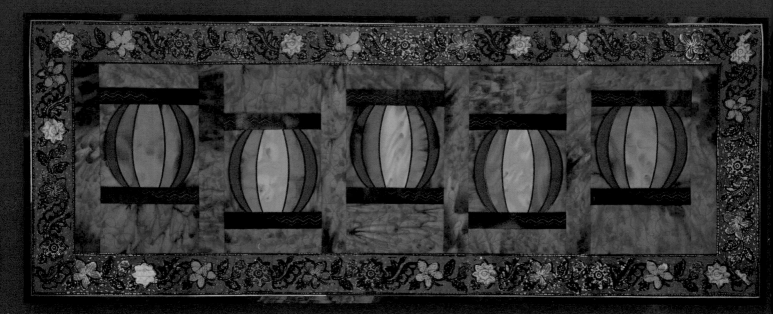

Piping Hot Mexican Lanterns
Susan K Cleveland, 63"x49", 2006

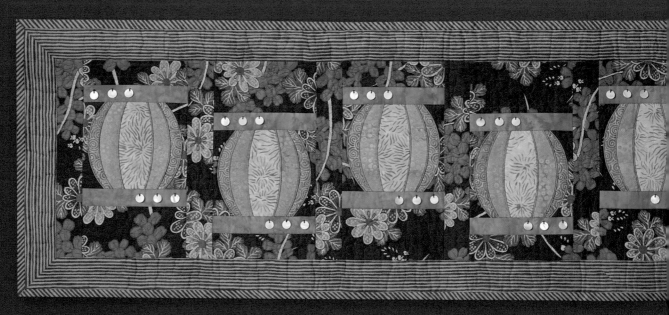

Piping Hot Japanese Lanterns
Susan K Cleveland, 63"x49", 2006

Piping Hot Lanterns

45" x 17"

About this project

Each lantern will be built from the background up. There are six curves in each block, but they are gentle and easy to stitch. I had fun embellishing the bases and tops with thread, beads, and silk ribbon. You may have some good ideas to add a little something to your Piping Hot Lantern quilt.

Fabric choices

I used 3 bright hand-dyed fabrics for the Mexican lanterns quilt and 3 batiks for the Japanese quilt. Piping fabric was repeated for lantern tops and bases.

The border print in my Mexican quilt is from a large piece of Malaysian batik that had wonderful borders printed on the lengthwise grain. If you wish to cut borders without piecing them, you'll need extra fabric, but when you find a print as great as this, it's worth the extra expense. I used more of this fabric on the back and for other projects. Visit www.BoldOverBatiks.com to get beautiful Malaysian batiks.

My Japanese quilt showcases a print from Japan in the background. It's interesting the feature fabric in this project may be the background or the border.

Supplies (fabric, thread, cording)

Results will be better if all fabrics (other than piping fabrics) are starched prior to cutting.

Fabric/Thread/Cording	Shown in Mexican sample	Amount needed
Cording for piping	¹⁄₁₆″ or 1.5mm	7 yds
Border	batik	½ yd OR 1½ yd for solid borders without piecing
Background	blue	½ yd
Lantern A	red	fat quarter, 18″x20″
Lantern B	orange	fat quarter, 18″x20″
Lantern C	gold	fat eight, 9″x20″
Lantern tops/bases	black	fat eight, 9″x20″
Piping	black	½ yd (enough for tops/bases also)
Binding (to be cut 2¼″)	black	⅜ yd
Piping in binding (instructions not included)	various pieces	fat quarter total
Cording for piping in binding	1.5mm	5 yds
Backing		¾ yd
Thin thread for applying piped lanterns: YLI #100 silk, or another thin thread to match lantern/piping fabric or invisible		
Thread for piecing and making piping: #50 or #60 cotton to coordinate with background/piping fabric		

Equipment

Please see "Supplies & Equipment" on page 6 for equipment.

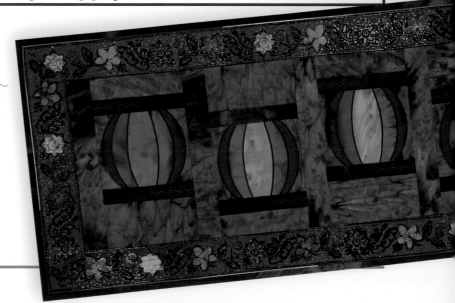

Cutting

Results will be better if all fabrics (other than piping fabrics) are starched prior to cutting.

Please see "Cutting Basics" on page 24 for information to cut strips properly. Fabrics are cut normally, on crosswise grain. Piping strips are cut on the bias.

Fabric	Your fabric selections	Cutting instructions
Piping		*If you're using this same piece for lantern tops/bases, cut off a piece 7"x18' and set aside.* • 230" of 1¼" bias strips (43" of piping per block)
Background		• (2) 6½" strips, then cut into › (5) 5½"x 6½" pieces for lantern backgrounds › (5) 3½"x 6½" pieces for above/below lanterns › (5) 2"x 6½" pieces for above/below lanterns › (6) 2"x12" pieces for between blocks (it may be necessary to cut a 2" strip from yardage to get all of these pieces)
Lantern A/B/C		to be cut later
Lantern tops/ bases		• (10) 1½"x 6½" pieces
Border		*If you're working with a 1½ yd piece:* • Cut (3) 2½" strips (side borders will be cut from one strip) *If you're working with a ½ yd piece:* • Cut (4) 2½" strips to piece (2) borders at least 47" in length and (2) borders at least 19" in length.
Binding		• 140" of 2¼" straight-grain OR bias strips
Backing		• 49"x21"

Notes

All seam allowances for piecing are ¼". I suggest a stitch length of 2.0mm for piecing.

Make piping

Each lantern requires 43″ of piping so a total of 215″ is needed. Follow instructions in "Perfect Piping" on page 14. Remember to pre-shrink cording and trim seam allowance of finished piping! The Groovin' Piping Trimming Tool makes this task quick and easy. Use matching thread in the needle and slightly contrasting thread in the bobbin.

Prepare templates

• Make triple-thick freezer paper Lantern A, Lantern B, and Lantern C templates as instructed on the template page 61. Each template will be used once for each block.

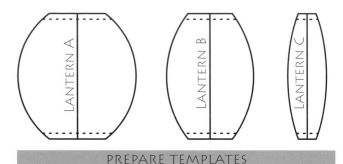

PREPARE TEMPLATES

Apply piping to lanterns

This section will be repeated for each of 5 blocks after these shapes are assembled into a block.

• With a *dry* iron, press freezer paper templates Lantern A, Lantern B, and Lantern C shiny side down, to *right* sides of chosen fabrics. One Lantern A, one Lantern B and one Lantern C are needed for each block.

• Cut fabric at least ⅜″ from edges.

• Sew piping along curves. This stitching line must be closer to cording than previous stitching.

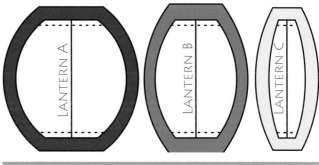

PRESS TEMPLATES TO RIGHT SIDE FABRIC

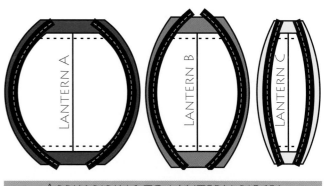

APPLY PIPING TO LANTERN PIECES

TIPS

See "Apply Piping" on page 17 for details

Place fold/cording beside template with matching or clear thread against fabric

Use an open-toe foot

Stitch beside cording with 1.5mm stitch length

Try different needle positions

Righties may have best results sewing clockwise and lefties counter-clockwise

- Trim lantern's curved seam allowance a bit narrower than piping seam allowance. Do not remove freezer paper! If you're concerned about piping fabric shadowing, trim lantern's seam allowance a bit wider than piping's seam allowance.

- From wrong side, press seam allowances to wrong side of lantern along stitching line. Do not remove templates!

TIPS

See "Press/Trim Seam Allowances" on page 18 for details

Smooth curve from right side with a stiletto and press

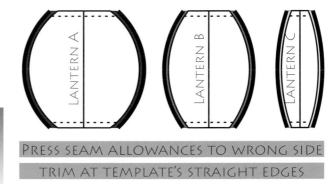

PRESS SEAM ALLOWANCES TO WRONG SIDE
TRIM AT TEMPLATE'S STRAIGHT EDGES

- Trim piping/lanterns at straight edges even with template. Do not remove templates!

Apply piped lanterns

- Place piped Lantern A on background 5½″ x 6½″ piece. Align straight edges and centers. Tape in place.

- Stitch in the ditch between piping and lantern.

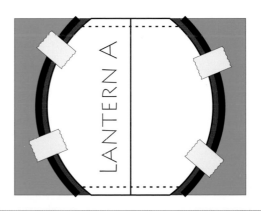

STITCH IN DITCH BETWEEN
LANTERN AND PIPING

TIPS

See "Apply Piped Shape" on page 20 for details

Use an open-toe foot

Stitch with 1.5mm stitch length with thin or clear thread

Try different needle positions

Try sewing from different directions

Hold a stiletto/awl in the ditch while sewing to open the ditch a little

Stop as needed with needle down to pivot

Righties may have best results sewing clockwise and lefties counter-clockwise

- Trim background from under Lantern A leaving a seam allowance a little wider than piping's seam allowance.

- Remove freezer paper so that it may be used on other fabrics.

- Add Lantern B and Lantern C in the same manner. Tape in place. Stitch in ditch. Trim fabric behind lantern. Remove template.

- Repeat "Apply Piping to Lanterns" and "Apply Piped Lanterns" to make 5 blocks.

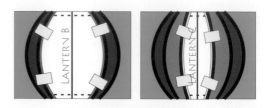

STITCH IN DITCH BETWEEN LANTERN B
AND PIPING THEN LANTERN C AND PIPING

Add tops/bases

- Optional: Stitch decorative pattern on bottoms/tops.

- Add 1½"x 6½" base and top to each lantern.

- Press seam allowances toward base/top.

ADD TOPS AND BASES

Add background

- Add a 2"x 6½" background to one end of each lantern. Press seam allowances toward lantern top/base.

- Add a 3½"x 6½" background to the other end of each lantern. Press seam allowances toward lantern top/base.

- Arrange blocks as shown with every other block upside down and add 2"x 12" background pieces between blocks and at each end. Press seam allowances toward background.

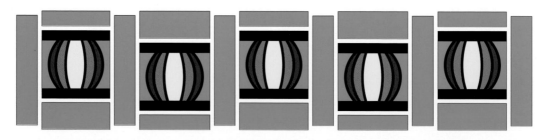

ADD BACKGROUNDS

Prepare for borders

• Splice border strips if necessary to produce (2) strips at least 47″ in length and (2) strips at least 19″ in length. Use diagonal seam and press seam allowances open.

• Measure width and length of quilt body through center and record these measurements.

• Add 2 times finished border width (for this project add 4″) to recorded width and length measurements and cut 2 top/bottom borders and 2 side borders from previously cut border strips.

• On wrong side of each border, place a pin the finished border width plus ¼″ from ends. For this project with a 2″ finished border, the pins should be 2¼″ from each end.

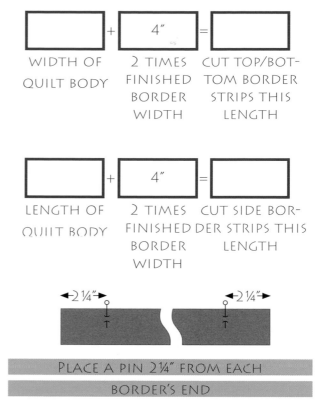

WIDTH OF QUILT BODY	+	4″ 2 TIMES FINISHED BORDER WIDTH	=	CUT TOP/BOT-TOM BORDER STRIPS THIS LENGTH

LENGTH OF QUILT BODY	+	4″ 2 TIMES FINISHED BORDER WIDTH	=	CUT SIDE BOR-DER STRIPS THIS LENGTH

←2¼″→ ←2¼″→

PLACE A PIN 2¼″ FROM EACH BORDER'S END

Attach/miter borders

• On wrong side of quilt, mark seam line intersections at corners.

• Attach each border by aligning pin on border with seam line intersection marked on back of quilt. Pin in place and sew with quilt body up without stitching past marked intersections. (Begin and end at a marked intersection.) Begin and end stitching line with 1.5mm stitches, use 2.0mm stitches in between. This will lock the stitches at each end. Press seam allowances toward border. Add each border stitching from intersection to intersection, moving previously sewn borders out of the way.

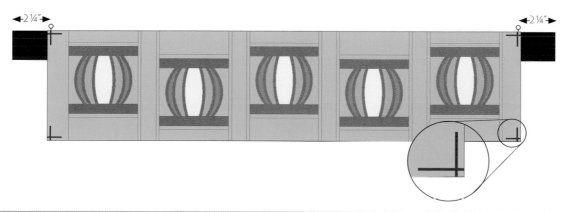

MARK SEAM LINE INTERSECTIONS, ATTACH BORDERS

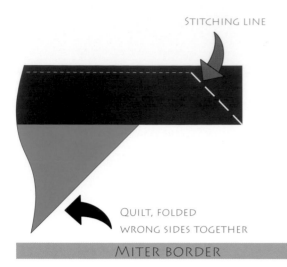

STITCHING LINE

QUILT, FOLDED
WRONG SIDES TOGETHER

MITER BORDER

• To miter each corner, place adjacent border ends right sides together and tuck quilt body between borders. Pin. Sew diagonally from end of border stitching line to corner of border. Press seam allowances open and trim to about ¼".

Finish

• Please be careful not to add too much quilting. Because this quilt contains so much cording in piping, the piece will not draw up or contract the way other quilts do when quilted. This is not the place to show off dense quilting. Follow the batting manufacturer's instructions for quilting density, but don't plan dense quilting.

• Stitch in the ditch around lantern tops, in piping ditches, and on border seams.

• Quilt background and borders. I quilted free-motion loops on background and wavy lines in borders.

• Some embellishment on lantern tops/bases might be nice.

• Add binding. My Lantern quilt has piping in the binding as taught in Piping Hot Binding. Please see resources section.

Lantern Templates

Each block requires (3) different triple-thick lantern templates. To make triple-thick template(s) see "Make Templates" on page 16. Add lines and labels as shown.

Righties will have best results stitching clockwise and lefties will have best results stitching counter-clockwise. Please record your preference on each template.

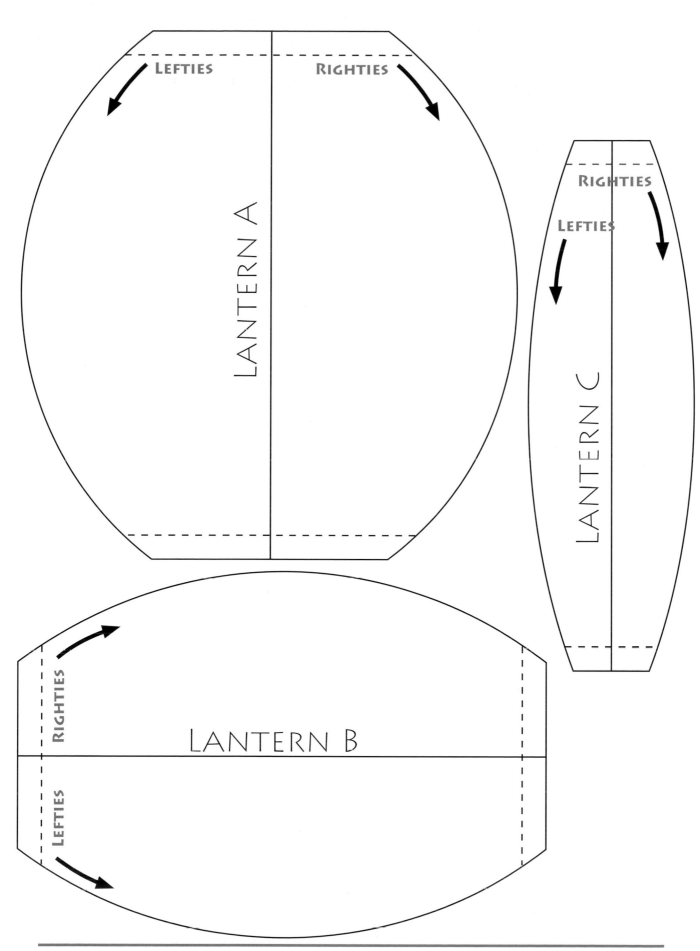

LEFTIES

RIGHTIES

LANTERN A

RIGHTIES

LEFTIES

LANTERN C

RIGHTIES

LANTERN B

LEFTIES

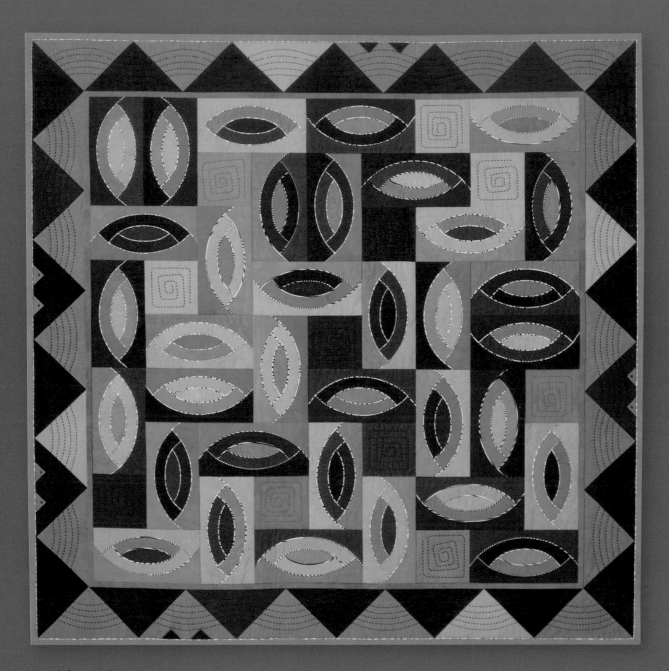

Hidden Tikis
Susan K Cleveland, 51"x51", 2007
blocks arranged by Darin Cleveland

Eye of the Piper

About this project

Gentle arcs make up each block of this project and they're quite simple to stitch. Since there are 4 piped arcs in each block, this project is more time consuming than previous projects. The new trick introduced is using a foundation to assemble each block. A center unit is pinned onto a foundation, then arcs are added using the foundation's edges as placement guides. After all arcs have been added, the foundation is removed and blocks are squared up. TaDa!

Fabric choices

Hand dyed fabrics are my favorite! Who can resist those tidy bundles of glorious color? This project is written for 8 fabrics plus piping fabric(s). It's ideal for an 8-step bundle of beauty. As is the case with all Piping Hot Curves projects, make sure there's plenty of contrast between the arc fabrics and piping. For piping in the small quilt, I chose another bundle of hand-dyed fabrics while in the larger quilt I chose three black & white fabrics…also irresistible.

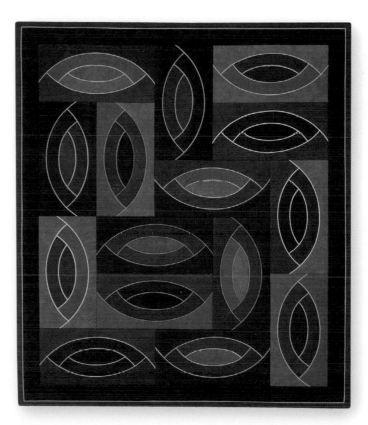

Pharaoh's Eye
Susan K Cleveland, 25"x30", 2005

Supplies (fabric, thread, cording)

Fabric requirements are based on 40–44″ wide fabric.

I chose hand dyed fabric bundles from Cherrywood Fabrics. The small quilt is made from an 8-step ½-yd bundle of Renaissance and a 4-step ¼-yd bundle of Ochre. This was enough for the quilt top, binding, backing and sleeve. The large quilt was made from an 8-step 1-yd bundle of Carnival and three ½-yd pieces of black and white prints. I purchased extra fabric for backing but the bundle and b/w prints were enough for the quilt top and binding.

FABRIC/CORDING/THREAD	SHOWN IN SAMPLES	LARGE QUILT AMOUNT NEEDED	SMALL QUILT AMOUNT NEEDED
Cording for piping	¹⁄₁₆″ or 1.5mm	42 yds	19 yds
Piping	large: black/white small: golds	(3) ½ yd pieces or (1) 1½ yd piece	(3) ¼ yd pieces or (1) ¾ yd piece
Blocks (centers & arcs) (large: plain squares)	large: brights small: deep colors	(8) ½ yd pieces	(8) ¼ yd pieces
Big border	large: brights small: none	(2) ½ yd pieces (triangles) (2) ¼ yd pieces (triangles)	none
Plain border	large: turquoise small: purple	(1) ¼ yd piece (plain border) —extra to play it safe	¼ yd
Binding (to be cut 2¼″)	large: turquoise small: deep red	½ yd	⅜ yd
Piping in binding (not included)	large: black/white small: gold	¼ yd	¼ yd
Backing		2½ yds	1 yd
Thin thread for applying piped arcs: YLI #100 silk or another thin thread to match arc/piping fabric or invisible			
Thread for piecing and making piping: #50 or #60 cotton to coordinate with block/piping fabrics			

Equipment

Please see "Supplies & Equipment" on page 6 for equipment.

• Foundation paper…specialty foundation paper, plain newsprint, or freezer paper

Cutting Instructions

Results will be better if all fabrics (other than piping fabrics) are starched prior to cutting.

Fabrics are to be cut normally, on crosswise grain,

Before cutting, review *"Cutting Basics"* on page 24.

FABRIC	YOUR FABRIC SELECTIONS	LARGE QUILT	SMALL QUILT
Piping		• 41 yds of 1¼″ bias strips (41″ of piping per block)	• 19 yds of 1¼″ bias strips (41″ of piping per block)
Blocks (centers & arcs)		• (3) 6″ strips from each of 8 different fabrics (OK if third strip is smaller)	• (1) 6″ strip from each of 8 different fabrics, cut extra strips as needed
Plain squares (large only)		• (11) 5″ squares of various fabrics	• none
Border 1		• 1″ strips to be cut later	• (4) 1½″ strips
Triangle border (large only)		• (9) 6¾″ squares cut diagonally of first color • (9) 6¾″ squares cut diagonally of second color • (2) 6¾″ squares cut diagonally of third color • (2) 6¾″ squares cut diagonally of fourth color	• none
Binding		• 210″ of 2¼″ straight-grain or bias strips	• 120″ of 2¼″ straight-grain or bias strips
Backing		• piece to make 56″x56″	30″x35″

Note

All seam allowances for piecing are ¼″. I suggest a stitch length of 2.0mm for piecing.

Make piping

• Each block requires 41″ of piping. 40 yds of piping are needed for large quilt and 18 yds are needed for small. I used three different fabrics and made piping as I needed it rather than all at once. Follow instructions in "Perfect Piping" on page 14. Please remember to pre-shrink cording and to trim finished piping's seam allowance. The Groovin' Piping Trimming Tool makes this task quick and easy. Use matching thread in the needle and slightly contrasting thread in the bobbin.

Prepare templates

• Make at least one triple-thick freezer paper template for each arc as instructed in "Make Templates" on page 16. Each template will be used many times, but you may wish to make several. Arc templates are at the end of this chapter.

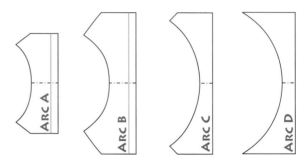

PREPARE TRIPLE-THICK TEMPLATE(S)

Prepare foundations

• Cut 10″x5½″ rectangles from foundation paper. Each block will require a foundation. Fold foundations in both directions to mark centers.

Large: 35 Small: 15

PREPARE FOUNDATIONS,
FOLD TO MARK CENTERS

Apply piping to arcs

The next two sections will be repeated for each block.

• An Arc A, Arc B, Arc C, and Arc D are needed for each block. With a *dry* iron, press freezer paper templates, shiny side down, to *right* side of chosen fabrics. Note that Arc A and Arc B may extend off the fabric's edge ⅝″. (Template's edge will be used as a placement guide later when piped arc is applied to block.) To make the best use of fabric, alternate which side the long edge is placed as shown. It is possible to cut 7 pieces from each strip. Future pieces are shown in grey.

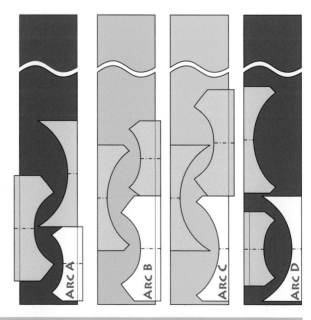

PRESS TEMPLATES TO **RIGHT** SIDE FABRIC

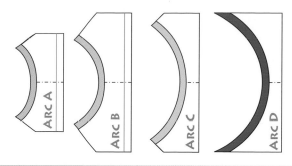

CUT FABRIC BESIDE
TEMPLATE'S STRAIGHT EDGES AND
AT LEAST 3/8" FROM CURVED EDGES

- Roughly cut fabric at least ³/8″ beyond curved template edges and along straight edges of template.

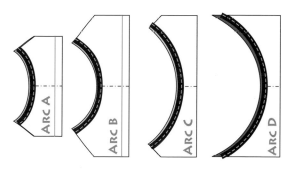

SEW PIPING ALONG CURVES

- Sew piping along curves. New stitching line must be closer to cording than piping stitching line.

TIPS

See "Apply Piping" on page 17 for details

Place fold/cording beside template with matching or clear thread against fabric

Use an open-toe foot

Stitch beside cording with 1.5mm stitch length

Try different needle positions

Righties may have best results sewing clockwise and lefties counter-clockwise

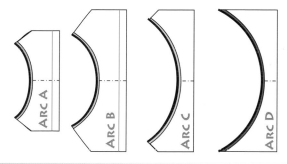

TRIM ARC SEAM ALLOWANCE
PRESS TO WRONG SIDE

- Along curved edges, trim arc seam allowances narrower than the piping seam allowance. Do not remove freezer paper! (If shadowing is a worry, trim arc seam allowances wider than piping seam allowance.)

- From wrong side, press seam allowances to wrong side along stitching line. Do not remove freezer paper!

TIPS

See "Press/Trim Seam Allowances" on page 18 for details

Occasionally, clipping may be necessary on a tight inside curve

Smooth curve from right side with a stiletto and iron

Apply piped arcs to foundation

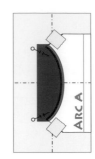

- Cut a 2"x5" block center from chosen fabric and pin in center of foundation. Align centers.

- ***Place long edge of Arc A's freezer paper template along long edge of foundation*** matching centers and tape in place. It's OK when fabric doesn't extend to template's edge.

- Stitch in the ditch between piping and arc.

PIN BLOCK CENTER ON FOUNDATION,
ADD ARC A, TRIM EXCESS CENTER FROM
UNDERNEATH ARC A,
REMOVE FREEZER PAPER TEMPLATE

TIPS

See "Apply Piped Shape" on page 20 for details

Use an open-toe foot

Stitch with 1.5mm stitch length with thin or clear thread

Try different needle positions

Try sewing from different directions

Hold a stiletto/awl in the ditch while sewing to open the ditch a little

Stop frequently with needle down to pivot

Righties may have best results sewing clockwise and lefties counter-clockwise

- Trim excess block center from under piping seam allowance leaving about a $^3/_8$" seam allowance. If you're concerned about shadowing, trim block center seam allowance narrower than piping's seam allowance.

- Remove freezer paper but leave foundation in tact.

- Repeat for Arc B, Arc C, and Arc D. Pin previous piece in place, tape new arc in place, stitch in ditch, trim excess fabric under each new arc, and remove freezer paper.

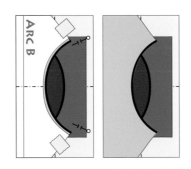

ADD ARC B
TRIM EXTRA UNDERNEATH
REMOVE FREEZER PAPER

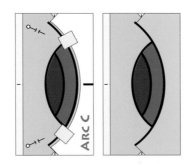

ADD ARC C
TRIM EXTRA UNDERNEATH
REMOVE FREEZER PAPER

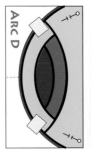

ADD ARC D
TRIM EXTRA UNDERNEATH
REMOVE FREEZER PAPER

- Remove foundation and ***trim block to 9½"x5"***.

- Repeat "Apply piping to arcs" and "Apply piped arcs to foundation". Large: 35 Small: 15

Assemble quilt body (small)

- Arrange blocks on a design wall. (Make sure each block has been trimmed to 9½"x5".)

- Assemble sections pressing seam allowances as shown. Sometimes it's necessary to press a seam in two directions. Clip the seam allowance at an angle to within a couple threads of the stitching, so part of the seam can be pressed in one direction and the rest in the other direction. This is done to avoid pressing piping back onto itself.

- Sew partial seam shown in blue, then add top left section, lower left section, lower right section, and complete partial seam.

ASSEMBLE EACH SECTION

BEGIN WITH PARTIAL SEAM

DESIGNATED IN BLUE

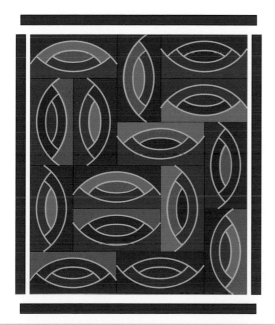

ADD BORDERS

Add border (small)

- Measure length of quilt through center and cut (2) previously cut 1½" border strips this length.

- Add those strips to right and left of quilt pressing seam allowances toward border.

- Measure width of quilt through center and cut (2) previously cut 1½" border strips this length.

- Add those strips to top and bottom of quilt pressing seam allowances toward border.

Assemble quilt body (large)

- Arrange blocks on a design wall.

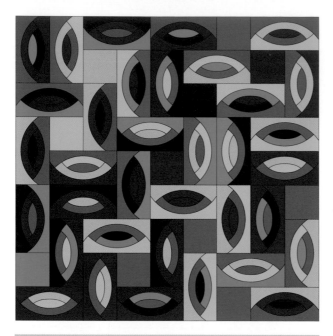

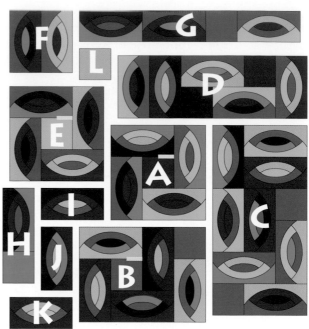

- Assemble units A, B, C D, E, F, G and H pressing seam allowances away from piping in seams. Sometimes it's necessary to press a seam in two directions. Clip the seam allowance at an angle to within a couple threads of the stitching so part of the seam can be pressed in one direction and the rest in the other direction. This is done to avoid pressing piping back onto itself.

Units A, B, and E require the use of partial seams. Start with the block at the top of the center square. Partially sew it to the square as noted with a heavy white line then work around the square clockwise adding blocks until it's possible to complete the partial seam.

Other units are straightforward.

This piecing is tricky, hang in there and be patient!

- Partial seam J to H (lower ½ of J)

- Add K

- Partial I to J (left ½ across top of J)

- Complete H to IJ seam (top ½ along H)

- Add E

- Add B beside JK

- Partial seam EI unit to A (lower ½)

- Complete seam across top of BJ to IA

- Add C

- Add D

- Lay large pieced unit aside (ABCDEHIJK)

- Partial seam L to F (lower ½ of L)

- Add LF to top of E

- Complete partial seam between AD and EFL

- Add G to top of LD

- Complete partial seam beside F

- Pat yourself on the back, call a friend about your accomplishment then take a nap.

Add borders

Piecing needs to be very accurate for this border to fit properly. You may wish to cut the inside border wider than 1″, add it to the quilt body, piece triangle borders, then cut the plain border to make the triangle border fit.

- Cut (6) 1″ strips for plain border or wider in order to make triangle border fit your quilt.
- Measure length of quilt through center and cut (2) plain border strips this length.
- Add those strips to right and left of quilt pressing seam allowances toward border.
- Measure width of quilt through center and cut (2) plain border strips this length.
- Add those strips to top and bottom of quilt pressing seam allowances toward border.
- Make border triangle template by cutting a 6¾″ square and then cut diagonally.
- Cut triangle border pieces from previously cut strips using triangle template.
- Piece as shown pressing toward outer triangles.
- If plain border was cut wider than 1″, measure and trim plain border so triangle border will fit.
- Add triangle border sides/top/bottom then corners.

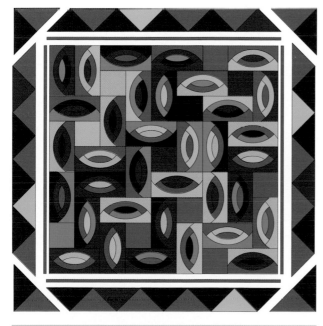

ADD PLAIN BORDER
ASSEMBLE TRIANGLE BORDER
ADD TRIANGLES BORDER

Finish

Be careful not to add too much quilting. Because this quilt contains cording in the piping, the piece will not draw up the way other quilts do when quilted. Follow the batting manufacturer's instructions for appropriate quilting density, but don't plan dense quilting.

- Quilt in the ditch.
- On the large quilt I added big stitch hand quilting with No. 8 pearl cotton in plain blocks and borders.
- The small quilt looked nice without decorative quilting. I let the colors and piping sing without distraction from more stitching.
- Add binding, label and sleeve. I added piping in the binding as taught in Piping Hot Binding. See "Resources" on page 94. On the large quilt, I couldn't resist adding prairie points.

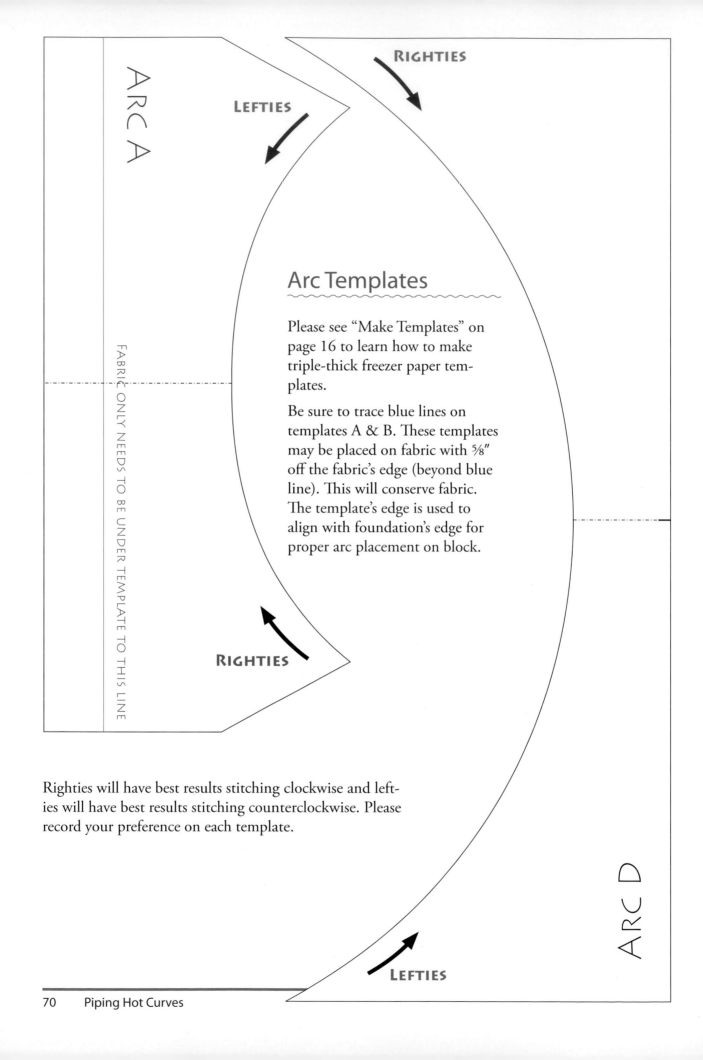

Arc Templates

Please see "Make Templates" on page 16 to learn how to make triple-thick freezer paper templates.

Be sure to trace blue lines on templates A & B. These templates may be placed on fabric with ⅝" off the fabric's edge (beyond blue line). This will conserve fabric. The template's edge is used to align with foundation's edge for proper arc placement on block.

ARC A

LEFTIES

RIGHTIES

FABRIC ONLY NEEDS TO BE UNDER TEMPLATE TO THIS LINE

RIGHTIES

ARC D

LEFTIES

Righties will have best results stitching clockwise and lefties will have best results stitching counterclockwise. Please record your preference on each template.

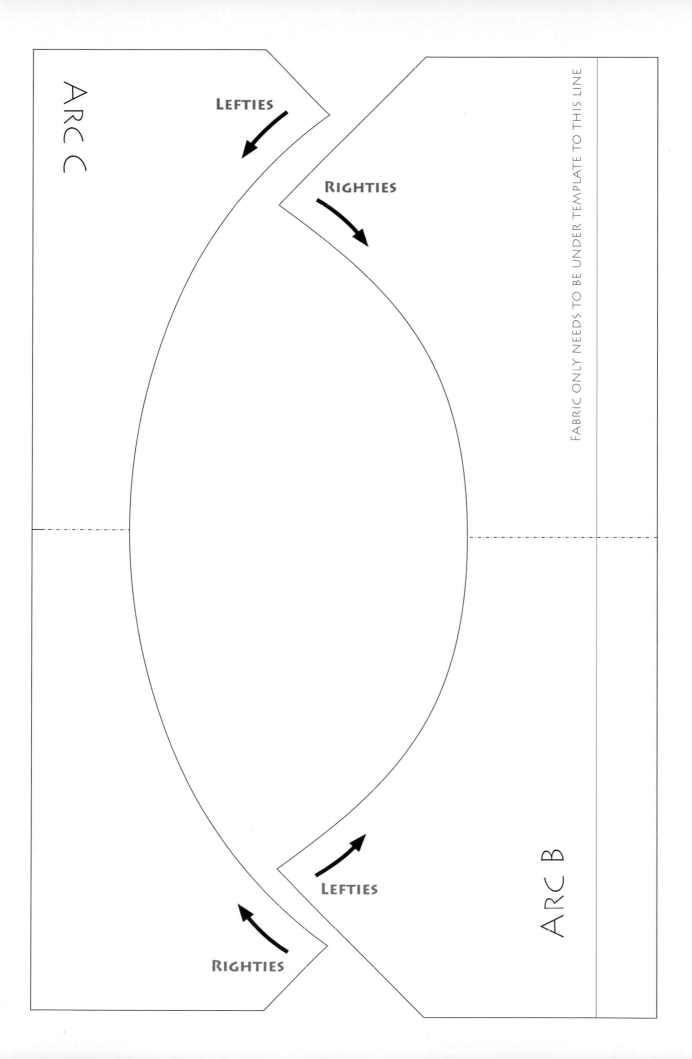

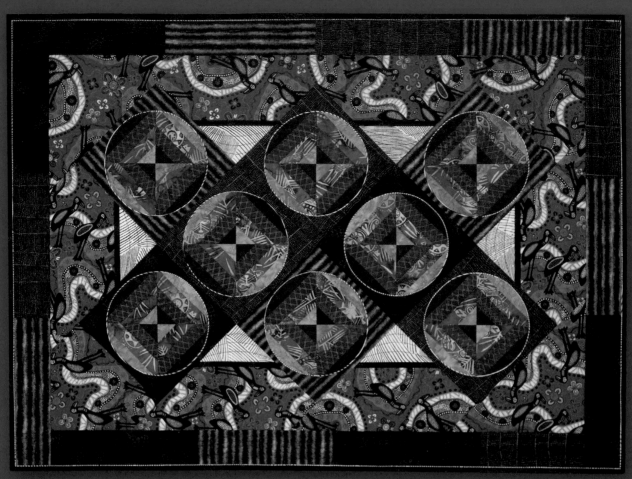

Gooney Bird Nests
Susan K Cleveland, 56"x41", 2005

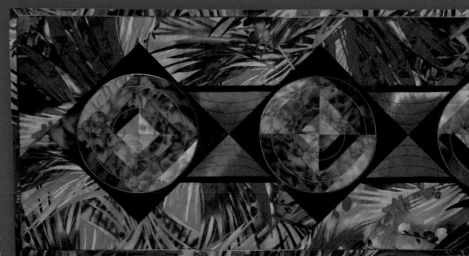

Rainforest Puddles
Susan K Cleveland, 50"x20", 2006

Square Peg Round Hole

56"x 41" or 50"x 20"

About this project

While there is not a great deal of piping in this project, one new skill is presented. Completing a circle with piping is covered in "Back to the beginning" in the "Technique" chapter on page 22. It's just a little tricky to overlap the piping where tails meet.

Fabric choices

This project looks great with both commercial prints and hand-dyed fabrics. Gooney Bird Nests began with the large border print. I pulled batiks to coordinate with the print and then dark animal prints to frame those beauteous batiks in orange and pink. When I saw the print that eventually became piping I was ecstatic. I knew this would make amazing piping and after I'd used it, I immediately tracked it down and purchased more. (I'm aware you do the same thing so you've no right to think it's silly.) I even found it in another color way and snatched that also.

Rainforest Puddles experienced a difficult beginning. I'd made the blocks with Malaysian hand-dyes to be used with a Malaysian batik I love, but when the two were together, they looked too matchy-matchy. The original blocks found a beautiful large print commercial fabric and I made different blocks to go with the original border fabric.

Supplies (fabric, thread, cording)

Fabric requirements are based on 40–44″ wide fabric.

FABRIC/CORDING/THREAD	SHOWN IN SAMPLES	LARGE QUILT AMOUNT NEEDED	SMALL QUILT AMOUNT NEEDED
Cording for piping	1/16″ or 1.5mm	8 yds	3 yds
Blocks	large: pink/orange small: blue/purple/green	(4) ½ yd pieces	(4) ¼ yd pieces (long or fat quarters)
Frames/ Thin border/ Outer border (lg only)	large: dark animal prints small: black	(3) ¾ yd pieces or 1¾ yds	(3) ½ yd pieces or cut everything from (1) ½ yd piece
Piping/ Setting triangles	large: cream/brown small: orange	½ yd	⅜ yd
Wide border	large print	1⅛ yd	1 yd
Binding	large: dark animal prints small: large print	½ yd	⅜ yd
Backing		1¾ yds	1½ yds
Thin thread for applying piped frames: YLI #100 silk or another thin thread to match frame/piping fabric or invisible			
Thread for piecing and making piping: #50 or #60 cotton to coordinate with block/piping fabrics			

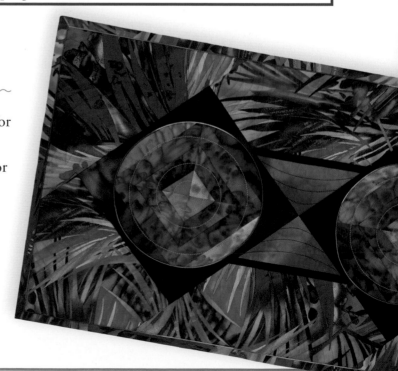

Equipment

Please see "Supplies & Equipment" on page 6 for equipment.

• Gridded pressing surface at least 12″ square or heavily starched light colored fabric with 11½″ square drawn in permanent marker.

• Acrylic ruler at least 15″ square, optional.

Cutting Instructions

Results will be better if all fabrics (other than piping fabrics) are starched prior to cutting.

Fabrics are to be cut normally, on crosswise grain.

Before cutting, review "Cutting Basics" on page 24.

Fabric	Your Fabric Selections	Large Quilt	Small Quilt
Blocks		• to be cut later	• to be cut later
Frames/ Thin border/ Outer border (lg only)		• (8) 11½" squares, may be cut from various fabrics for frames • (2) 1" strips for thin border • (15) 3½"x13"–17" pieces from various fabrics for outer border (lengths vary)	• (3) 11½" squares, may be cut from various fabrics for frames • (1) 1" strip for thin border
Piping/ Setting triangles		• (2) 8¼" squares cut diagonally twice (in an X) for setting triangles, (6) triangles needed • 260" of 1¼" bias strips (31"of piping per block)	• (1) 8¼" square cut twice diagonally (in an X) for setting triangles • 110" of 1¼" bias strips (31" of piping per block)
Wide border		• (3) 6½" strips • (2) 13½" squares cut diagonally once	• (2) 6½" strips • (2) 13½" squares cut diagonally once
Binding		• 210" of 2¼" straight-grain or bias strips	• 160" of 2¼" straight-grain or bias strips
Backing		• 61"x44"	• 56"x26"

Note

All seam allowances for piecing are ¼". I suggest a stitch length of 2.0mm for piecing.

Make piping

- Each block requires 31″ of piping. 248″ of piping is needed for large quilt and 93″ is needed for small. Follow instructions in "Perfect Piping" on page 14. Please remember to pre-shrink cording and to trim finished piping's seam allowance. The Groovin' Piping Trimming Tool makes this task quick and easy. Use matching thread in the needle and slightly contrasting thread in the bobbin.

Make blocks

- Make block template from whatever you have on hand. I like semi-transparent plastic template material but you may use freezer paper. Cut an 8⅝″ square and cut once diagonally. Draw lines 2″ from the long edge, 1¼″ up from the first line, and another 1¼″ up from the second line as shown.

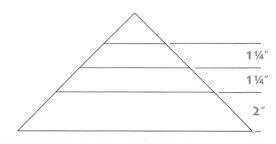

MAKE BLOCK TEMPLATE

- Arrange 4 block fabrics in gradation of light to dark or from one color to another. Assign letters A, B, C, and D.

- From fabrics A and D, cut 2¼″ strips. Large: (6) strips. Small: (2) strips or 6 if cutting from fat quarters.

- From fabrics B and C, cut 1¾″ strips. Large: (6) strips. Small: (2) strips or 6 if cutting from fat quarters.

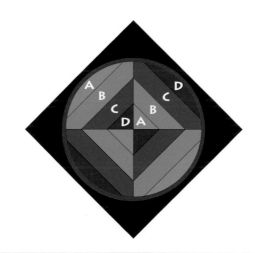

CHOOSE & LABEL BLOCK FABRICS

- Sew strip sets as shown and ***press all seam allowances toward fabric D***. Each strip set will yield enough triangles for 1½ blocks if strips are staggered as shown Begin B 2″ from end of A. Begin C 1¼″ from end of B. Begin D 1¼″ from end of C. Large: (6) sets. Small: (2) sets or (6) with fat quarters.

- Use Block template to cut pieces as shown. Align drawn lines on template with seam lines. Note the template does not reach from edge to edge. Large: 32 triangles. Small: 12 triangles.

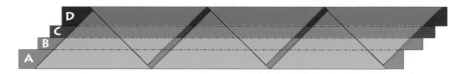

SEW STRIP SETS, USE BLOCK TEMPLATE TO CUT TRIANGLES

• Paying close attention to orientation, sew block halves then complete blocks as shown. If seams were pressed correctly, seam allowances will nest together to make matching intersections easy. These seams are bias, so be careful not to stretch seams! If your machine tends to stretch bias edges, piece blocks with a walking foot. Press in direction of arrow for half blocks. Press in any direction when joining halves. Large: 8 blocks. Small: 3 blocks.

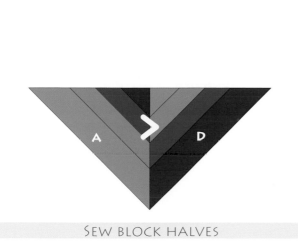

SEW BLOCK HALVES

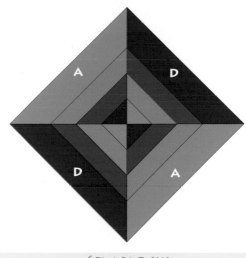

SEW BLOCKS

Prepare frame template

• Make at least one triple-thick freezer paper frame template as instructed in "Make Templates" on page 16. This template can be used many times, but you may wish to make several. On a triple-thick freezer paper stack larger than 13″ square, draw an 11½″ square and mark an X through the center. Use a compass to draw a circle in the center with a 4¾″ radius (9½″ diameter). You may make this circle a bit smaller, but not larger. Cut on lines and discard circle.

PREPARE FRAME TEMPLATE(S)

Apply piping to frame

The next two sections will be repeated for each block. Large: 8 blocks. Small: 3 blocks.

• With a *dry* iron, press freezer paper frame template, shiny side down, to *right* side of frame fabric 11½″ square.

• Sew piping along curve. Cording must lay beside freezer paper template. New stitching line must be closer to cording than piping stitching line. Review "Back to the beginning" in the Technique chapter on page 22. Note your freezer paper template and piping may be mirror image of those photos. The photos show piping a circle rather than a hole. Overlap piping as shown bending tails into seam allowance. Do not remove freezer paper.

APPLY PIPING

TIPS

See "Apply Piping" on page 17 for details

Place fold/cording beside template with matching or clear thread against fabric

Use an open-toe foot

Stitch beside cording with 1.5mm stitch length

Try different needle positions

Righties may have best results sewing clockwise and lefties counter-clockwise

• Along curved edge, trim frame seam allowance narrower than piping seam allowance. Do not remove freezer paper! If shadowing is a worry, trim frame seam allowance wider than piping seam allowance.

• From wrong side, press seam allowances to wrong side along stitching line. Do not remove freezer paper! Smooth curve from right side.

TIPS

See "Press/Trim Seam Allowances" on page 18 for details

Occasionally, clipping may be necessary on a tight inside curve

Smooth curve from right side with a stiletto and iron

TRIM & PRESS SEAM ALLOWANCE

Leave freezer paper on each unit until it has been applied to block!

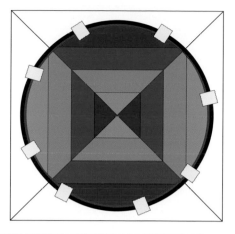

Apply piped frame to block

• Place piped frame over block aligning straight edges. If pieces aren't exactly the same size, center block under frame. Tape in place.

• Stitch in the ditch between piping and frame. Trim block from under frame leaving about a 3/8" seam allowance. If shadowing is a concern, trim frame seam allowance narrower than piping seam allowance.

APPLY PIPED FRAME TO BLOCK

TIPS

See "Apply Piped Shape" on page 20 for details

Use an open-toe foot

Stitch with 1.5mm stitch length with thin or clear thread

Try different needle positions

Try sewing from different directions

Hold a stiletto/awl in the ditch while sewing to open the ditch a little

Stop frequently with needle down to pivot

Righties may have best results sewing clockwise and lefties counter-clockwise

• Remove freezer paper so that it may be used on other fabrics.

• Pin block to gridded pressing surface squaring up to 11½". If a gridded pressing surface is unavailable, pin a heavily starched, light colored fabric with an 11½" square drawn in permanent marker over your pressing surface then pin the block to that. *Steam.* Let cool before removing pins. This will help the block lay flat.

• ***Trim completed block to 11" square being careful to keep center of block 5½" from cut edges (centered).***

• Repeat "Apply piping to frame" and "Apply piped frame to block". Large: 8 blocks. Small: 3 blocks.

TRIM BLOCK SEAM ALLOWANCE
THEN REMOVE FREEZER PAPER

Prepare border units

• Trim (2) wide border triangles (previously cut) to make 11″-wide "home plate" shapes for corners. Stack (2) wide border triangles. Place 5½″ line of ruler on point of triangle, make sure a line of the ruler is along the triangle's long edge. Trim. Turn triangles 180° and repeat.

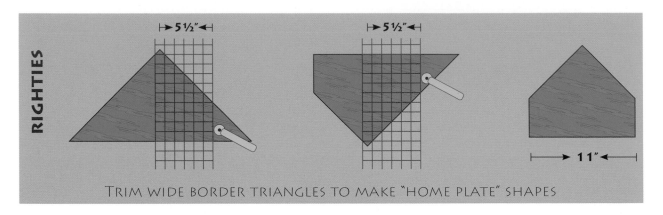

TRIM WIDE BORDER TRIANGLES TO MAKE "HOME PLATE" SHAPES

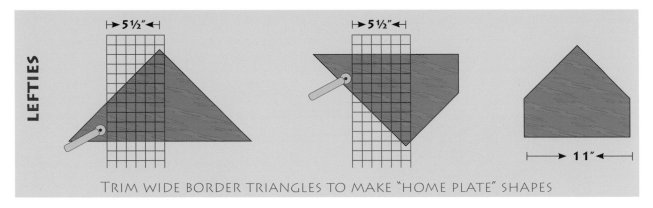

TRIM WIDE BORDER TRIANGLES TO MAKE "HOME PLATE" SHAPES

• Cut 9½″ lengths from previously cut 1″ thin border strips. Large: 6 pieces. Small: 4 pieces.

• Match centers and sew these pieces to long edge of setting triangles. Press toward thin border strips. Large: 6 units. Small: 4 units.

SEW THIN BORDER PIECES TO LONG SIDE OF SETTING TRIANGLES

• Sew setting triangle/thin border units to 6½" wide border strips as shown and press toward thin border strip. Cut triangle with large square ruler by placing corner of ruler over corner of setting triangle. If you don't have a large square ruler, cut a 15" square of freezer paper then cut diagonally to use as a template. Large: 6 big triangles. Small: 4 big triangles.

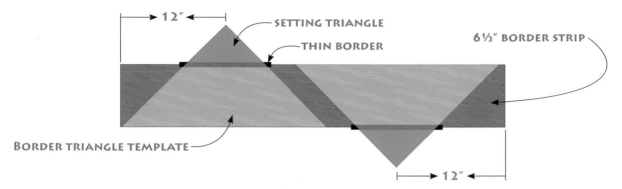

SETTING TRIANGLE
THIN BORDER
6½" BORDER STRIP
BORDER TRIANGLE TEMPLATE
12"
12"

SEW SETTING TRIANGLE/THIN BORDER UNIT TO WIDE BORDER STRIP, CUT TRIANGLES

• *Carefully* trim border units to 11" wide as shown. Note that for large quilt two pieces are reverse of the other four. Use an additional ruler or make a mark 11" from the corner to determine cutting line.

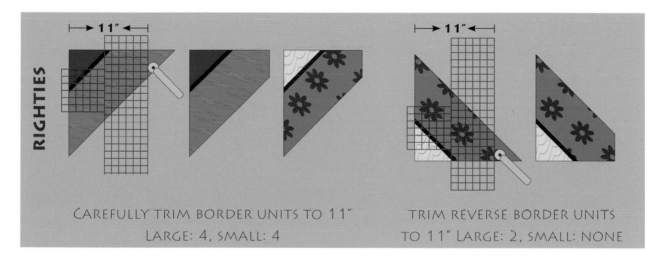

RIGHTIES

11"
11"

CAREFULLY TRIM BORDER UNITS TO 11"
LARGE: 4, SMALL: 4

TRIM REVERSE BORDER UNITS
TO 11" LARGE: 2, SMALL: NONE

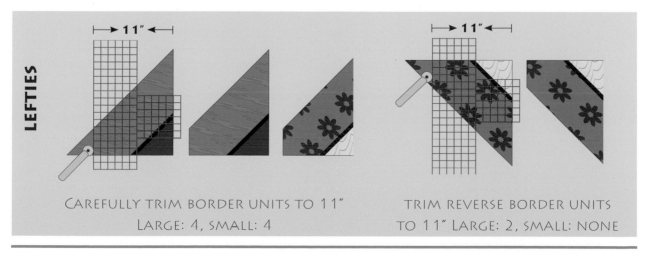

LEFTIES

11"
11"

CAREFULLY TRIM BORDER UNITS TO 11"
LARGE: 4, SMALL: 4

TRIM REVERSE BORDER UNITS
TO 11" LARGE: 2, SMALL: NONE

Assemble quilt body

• Arrange blocks (squared to 11″), border units, and corners on a design wall.

• Assemble rows and press seam allowances as shown. Sew rows together pressing seam allowances toward plain corners and rows with fewest blocks.

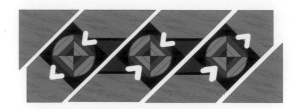

ARRANGE BLOCKS, SEW ROWS, ASSEMBLE ROWS

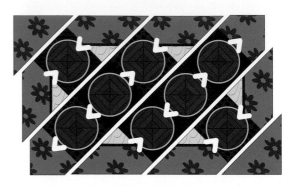

ARRANGE BLOCKS, SEW ROWS, ASSEMBLE ROWS

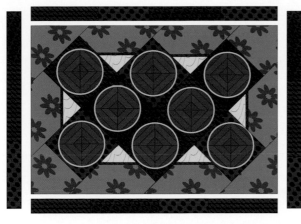

PIECE BORDER STRIPS

ADD BORDERS

TOP/BOTTOM THEN SIDES

- Large quilt only: Piece 3½"-wide outer border pieces end-for-end with a 1.5mm stitch length and press seams open. Measure quilt's width, cut pieces for top/bottom and add to quilt pressing seams toward border. Measure quilt's length, cut pieces for sides and add to quilt pressing toward border.

Finish

Please be careful not to add too much quilting. Because this quilt contains cording in the piping, the piece will not draw up the way other quilts do when quilted.

- Stitch in the ditch. I free-motion machine quilted in the borders and added smooth curves in the blocks and setting triangles.

- Add binding, label and sleeve. I added Piping Hot Binding. See "Resources" on page 94.

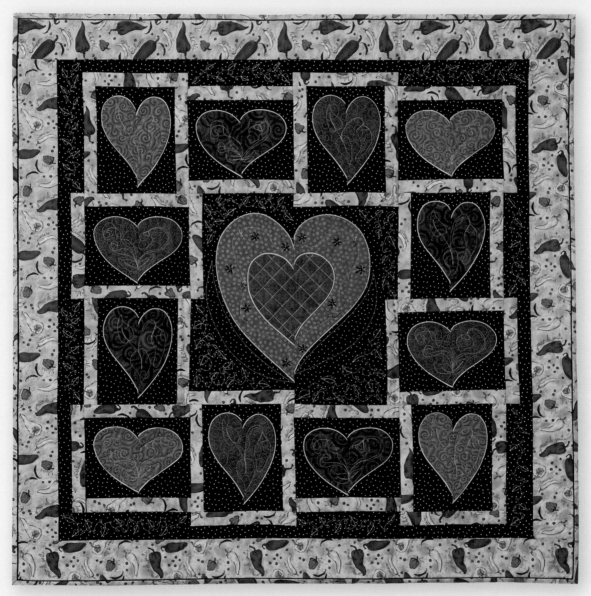

Susan's Piping Hotties Love Salsa
Beth Holec, 42"x42", 2005
designed by the author

Beth's attention to detail on this piece is wonderful. She's added flowing quilting lines and various sparkly beads to add interest to an already spicy quilt.

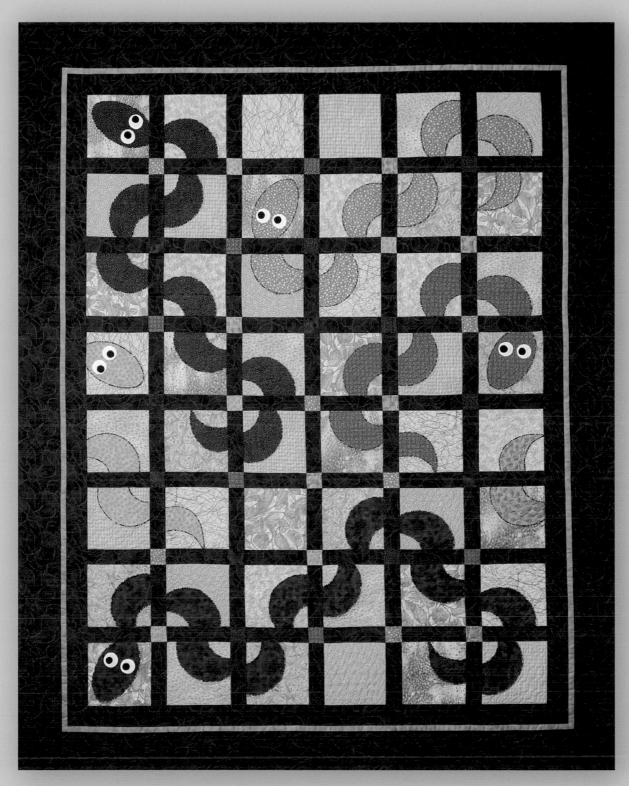

Whimsical Worms for Alex
Sharon Sandberg, 56"x71", 2007
quilted by Pat Drehobl of Stitch By Stitch in Rochester, MN
codesigned by the author and Darin Cleveland

Sharon's choice of striped fabric for piping adds to the playfulness of this quilt she made for her grandson.

Tic Tac O's
Kim Klocke, 34"x34", 2007
original design based on author's block

Kim began a different quilt with these circle blocks and then took another path with her original design. Circles won!

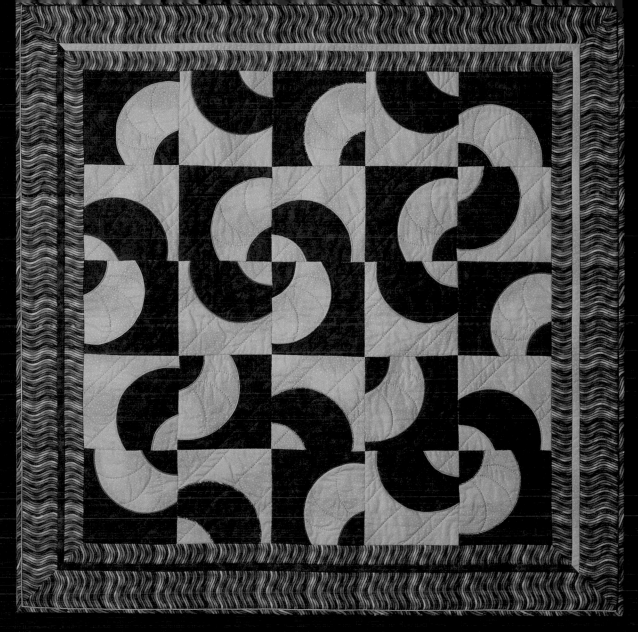

Macaroni
Synneva Hicks, 38"x38", 2006
original layout with blocks designed by author

Synneva's striped border no doubt influenced piping choices for her lively piece

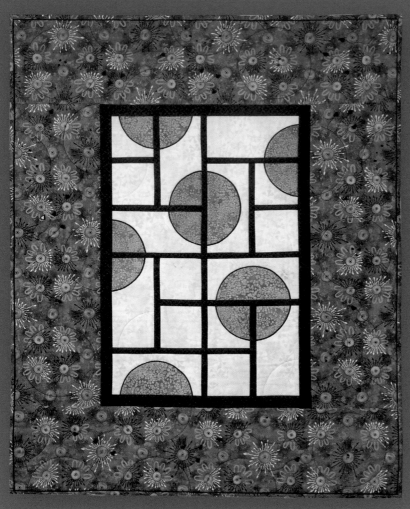

Windows
Beth Holec, 32"x40", 2006
designed by author

Dark piping is striking against a light background. Again, Beth has added beads in the border of this tranquil piece. They add just a hint of tasteful glitz.

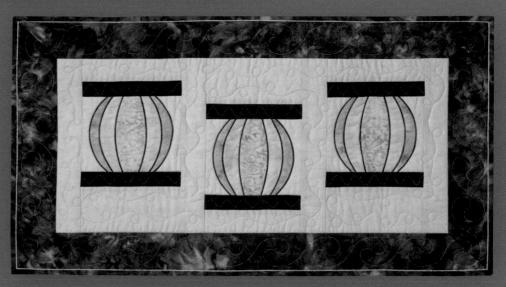

Lanterns
Synneva Hicks, 29"x17", 2006
original layout of blocks designed by author

While it's fun to do craziness with Piping Hot Curves, elegance can be achieved as shown in Synneva's piece.

Pretty Flaky

Susan K Cleveland, 40"x40", 1999

original design

...my first use of piping in curves.

Bouncin'
Susan K Cleveland, 63"x61", 2005
original design

This piece showcases piping inside and outside
the orange border and around circles behind stars.
Beads, prairie points and decorative threads add still
more punch.

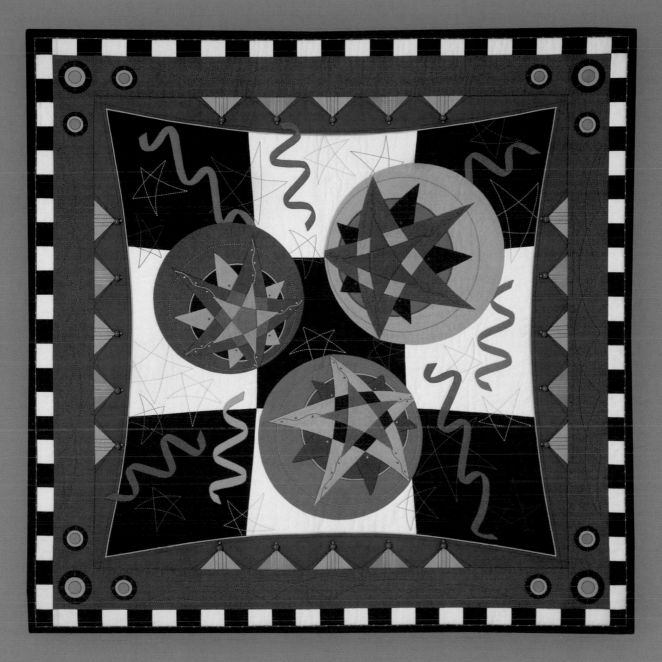

Bouncin' Threesome
Susan K Cleveland, 37"x37", 2006
original design

This piece showcases piping inside blue border and around circles behind stars. It was made after my kids suggested Bouncin', this quilts's mother, should have had brighter colors.

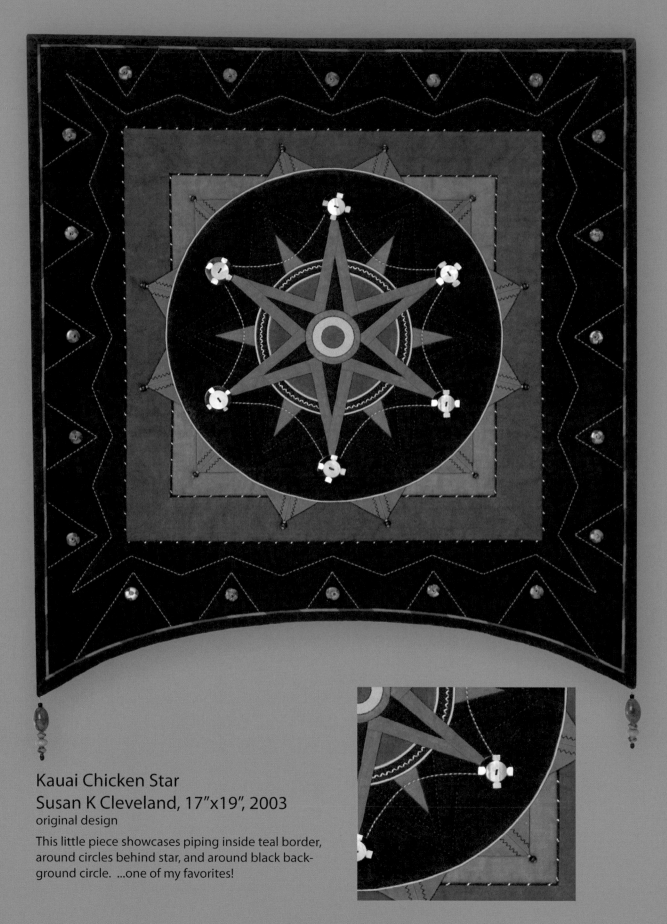

Kauai Chicken Star
Susan K Cleveland, 17"x19", 2003
original design

This little piece showcases piping inside teal border, around circles behind star, and around black background circle. ...one of my favorites!

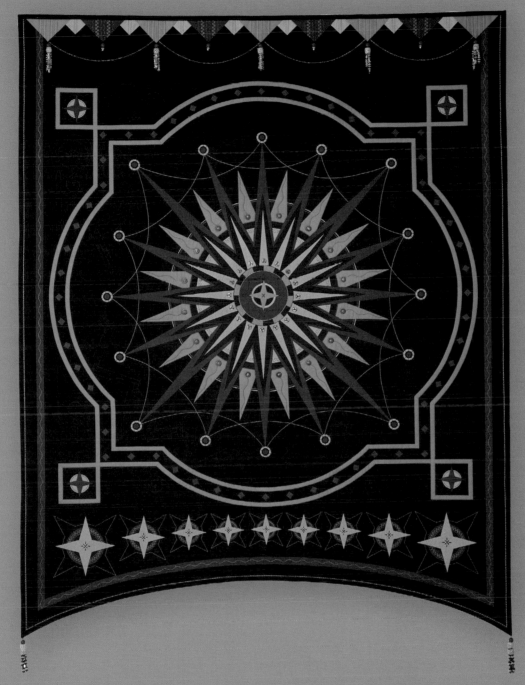

Carnival Star
Susan K Cleveland, 64"x82", 2003
original design

Yes, I like inserting piping into circles behind stars. I also enjoy stacked circles, prairie points, beaded tassels, and, of course, Piping Hot Binding.

Resources

Fabrics

- Cherrywood Fabrics, hand-dyed fabrics, www.CherrywoodFabrics.com
- Bold Over Batiks, Malaysian batik fabric, www.BoldOverBatiks.com

Thread

- YLI Corp., www.YLICorp.com
- Fabric Art Shop, all colors of YLI #100 silk thread, www.fabricartshop.com
- Uncommon Thread, www.UncommonThread.com

Batting

- Hobbs Heirloom® 100% Wool batting is in most of the quilts in this book. It can be found at many fine quilt shops.

Sewing machines and feet

- Bernina, www.Bernina.com
Try foot #23, #3, #32 or #33 for making piping (different feet work best on different models because of the variety of needle positions available), and use #20 for applying piping and stitching in the ditch.

- Pfaff, www.Pfaff.com
Use clear plastic applique foot for making piping and metal open-toe foot for applying piping and stitching in the ditch.

Other supplies and tools

- Freezer paper large rolls: Uline, www.Uline.com, 1-800-958-5463

- Brooklyn Revolver II: Come Quilt With Me, www.ComeQuiltWithMe.com

- Groovin' Piping Trimming Tool, cording, Piping Hot Binding, Clover ball-point awl, quilting patterns, classes/programs: Pieces Be With You, www.PiecesBeWithYou.com

Piping Hot Rocks (in progress)
Susan K Cleveland, 25"x34", 2006
original design